PORTRAIT DRAWINGS
XV-XX CENTURIES

An exhibition held in
the Department of Prints and Drawings
in the British Museum

2nd August to 31st December 1974

GERE

Published for **THE TRUSTEES OF THE BRITISH MUSEUM**
by BRITISH MUSEUM PUBLICATIONS LIMITED

1542

BNG (GER)

INTRODUCTION

The purpose of this exhibition is to illustrate, with the Printroom's resources, the development of the portrait drawing from the fifteenth century to the present day. The full extent of these resources may come as something of a surprise, for since the collection is classified by artists drawings of any one type are bound to be widely dispersed. The Printroom in fact possesses about six hundred portrait drawings. They are of all periods and schools, but the great majority are British, reflecting the numerical preponderance of that school in the collection as a whole. These, though haphazardly accumulated over the years, constitute a valuable supplement to the collections of the National Portrait Gallery. There has never been a separate catalogue of the Museum's collection of portrait drawings, and the absence of any indices to Binyon's British catalogue, which though long out of print and out of date is still the most complete record of that section of the collection, makes it useless for that purpose. The present publication does not deserve the title of catalogue, for it makes no claim to completeness either in scope or treatment. It is no more than an illustrated handlist of the 450 or so drawings selected for exhibition; but it has been very fully indexed, both by artists and by subjects, in the hope that in spite of its inadequacies it may be of some use as a work of reference.

The term 'portrait' does not cover indiscriminately any representation of a human being. Many such drawings are academic exercises, or fancy subjects, or studies for figures in paintings, and in all of these the human face and form tend to be treated with some degree of idealization and generalization. A portrait, in the true sense of the word, is a likeness in which the artist is engaged with the personality of his sitter and is pre-occupied with his or her characterization as an individual. The distinction can best be illustrated by citing one or two relevant borderline cases. Two of the finest Renaissance drawings in the collection, for example, the famous *Warrior* by Leonardo da Vinci and the *Woman's Head* by Verrocchio, had both to be excluded: the former at once, as being obviously an ideal head; the latter after some hesitation for notwithstanding the artist's pre-occupation with the details of the elaborate coiffure there is an element of idealization in the drawing that makes it seem a study for a Madonna rather than a likeness of a particular woman. On the other hand, the *Man's Head* by Raphael (no. 35), though probably part of the preparatory material for a painting, is rendered with an

intensity of psychological observation that makes it a true portrait, whatever may have been its primary purpose.

Once the portrait was satisfactorily defined, a further problem was to determine the scope of the exhibition. Should it include prints as well as drawings? No survey of portraiture in the graphic arts would be complete that did not include – to name only three outstanding groups of portrait prints – Rembrandt's etchings or Van Dyck's *Iconography* or those still undervalued masterpieces of interpretative engraving, the English mezzo-tints of the eighteenth and early nineteenth centuries. But the Museum collection proved to contain so many outstanding portrait drawings that it seemed best to concentrate on these and leave for another occasion the portrait prints, which alone would make a complete exhibition.

A third problem was that of striking the right balance between artistic and iconographic significance. Occasionally, as in Goya's *Duke of Wellington* (no. 325), a great artist and a great subject converge; but some of the finest portrait drawings – Dürer's *Conrad Merkel* (no. 21), for example, or Raphael's young Florentine lady (no. 33) – are of obscure or unknown people; conversely there are others of only slight artistic importance, such as Doyle's sketches of George IV (no. 347) and the Duke of Wellington (no. 364), that shed a vivid light on historic personages.

The exhibition spans a period of five hundred years. The first drawing in it, if not by Jan van Eyck himself, is a product of his immediate circle; the last (no. 412) is by David Hockney. Cases 1 to 27 (nos. 1 to 126) are arranged in chronological order, beginning with the early Netherlandish and German schools (some of these drawings, though familiar from recent exhibitions, will make a different impression in a fresh context) and going on to the Italian fifteenth and sixteenth centuries and the seventeenth century mainly in Italy and the Netherlands.

After this, the chronological sequence, which runs some risk of being monotonous, is interrupted in favour of an arrangement according to theme. The first and largest of these next sections, in Cases 28 to 44 (nos. 128 to 219) is of portraits of artists. Most of them are British; and since the most docile and patient model that any artist can hope to find is himself, they include a high proportion of self-portraits. Comparatively few of them represent artists actually at work, but those that do are some of the most interesting:

the self-portrait by the obscure eighteenth-century Florentine engraver, Giovanni Domenico Campiglia, in which the laborious technique is transformed into poetry by intensity of observation (no. 159); the red chalk sketch by Watteau of an engraver at his work-table (no. 155); William Hoare's charmingly intimate likeness of the miniaturist Friedrich Zincke in old age (no. 158); the tiny sketch by William Young Ottley, Keeper of the Department of Prints and Drawings from 1833 to 1836, of the sculptor Flaxman working on a model – the only one of these drawings to convey anything of the furious concentration of the creative act (no. 186). Mention must also be made of the particularly sympathetic and living likeness of J. M. W. Turner leafing through a volume of engravings in the Printroom, by J. T. Smith, Ottley's predecessor as Keeper (no. 187); and, as a curiosity, the large watercolour profile of the old woman 'who lived in a hut upon Epping Forest', drawn by Blake's pupil Frederick Tatham who had been struck by her astonishing resemblance to his master (no 182).

Two smaller sections follow: one (Cases 52 to 54; nos. 260 to 275) devoted to actors and musicians, the other (Cases 45 to 51; nos. 226 to 259) to caricature. Caricature may be defined as an impression of a type or individual expressed by the ludicrous or grotesque exaggeration of his most characteristic features. Ferraù Fenzoni's portrait of Nicodemo Ferruzzi (no. 225) is only just over the borderline between straight portraiture and caricature, but most of the drawings in this section are examples of the grotesque distortion first developed by Leonardo da Vinci towards the end of the fifteenth century and taken up by the Carracci and their Bolognese followers in the later sixteenth and seventeenth centuries. The earlier caricatures are mostly of types. It is not until later, with such draughtsmen as Bernini (of whom in this vein the Museum unfortunately does not possess an example), Mola and Maratta in the seventeenth century and Ghezzi and Zanetti in the eighteenth, that we find caricatures of individual persons. The section ends with Max Beerbohm (nos. 253 to 257) and his no less talented contemporary Henry Tonks (no. 258) whose caricatures are only less well known because they were made occasionally and for private circulation.

Finally, the chronological sequence is resumed. In Cases 55 to 76 (nos. 284 to 412) are British drawings from the sixteenth century to the present day, with the addition of a few belonging to other schools from the eighteenth

century onwards. The criterion here was largely one of historical interest, and wherever possible drawings have been grouped according to subject-matter or affinity: thus in Case 59 (nos. 306 to 311) are neo-classic portraits by Fuseli, Ingres and others; in Case 61 (nos. 318 to 324), late eighteenth century statesmen; in Case 62 (nos. 325 to 331) military and naval personalities of the Napoleonic period; in Case 63 (nos. 332 to 338), 'Phenomena, Convicts, etc.' – the title of a division of the traditional 'Bromley portrait classification' according to which the Museum's collection of engraved portraits is still arranged; in Case 68 (nos. 366 to 372), Pre-Raphaelite portraiture; in Case 71 (nos. 386 to 390), some of the literary personalities of the 1890's.

The exhibition ends with some modern examples which show that the art of portraiture still retains enough vitality to withstand the competition of the camera. This is sometimes said to be a dying art; but though there is little need today for the grand state portrait, there is likely always to be a demand for the small-scale intimate record. The photographer, however skilfully and wittily he seizes on the most characteristic or revealing aspects of his sitter, provides no proper substitute for the pondered assessment and interpretation of one personality by another that constitutes the essence of portraiture.

J. A. GERE

THE CATALOGUE

XV-XVI CENTURIES: ALL SCHOOLS

I
SCHOOL OF JAN VAN EYCK
(c. 1385-1441)

A MAN WEARING A CHAPERON
Metalpoint on cream-coloured prepared paper. 215:145

Only one drawing, that of Cardinal Albergati
(in Dresden), can be accepted without reserve as
by Jan van Eyck himself. The present drawing is
one of a number of portraits, close to him in style,
which have been attributed to him with varying
degrees of conviction. By comparison with some
of the others, the features of the sitter are more
stiffly drawn, but this might be explained by its
being a very early work.

Collection: Malcolm
1895-9-15-998

2
Attributed to ROGIER VAN DER WEYDEN
(1399/1400-1464)

HEAD OF A LADY
Metalpoint on cream-coloured prepared paper. 166:116

Possibly a contemporary copy of an early painting
by Rogier (cf. the portrait of a woman at Berlin-
Dahlem, datable c. 1435).

3
GERARD DAVID
(c. 1450-1523)

A FRANCISCAN FRIAR
Metalpoint and black chalk on grey prepared paper.
260:180

Though on a larger scale, the drawing is stylistic-
ally and technically similar to the portrait studies

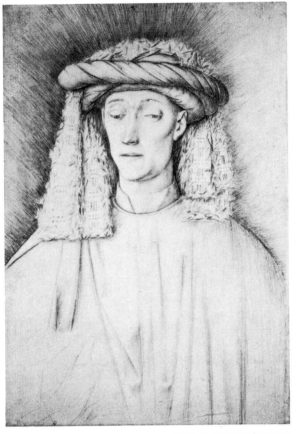

1 SCHOOL OF JAN VAN EYCK
A MAN WEARING A CHAPERON

on leaves from a dispersed album generally accep-
ted as being by David.

Collection: Malcolm

1895-9-15-999

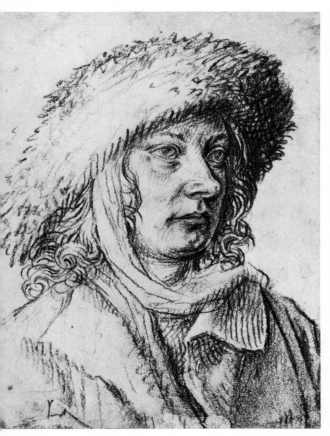

4 LUCAS VAN LEYDEN
A YOUNG MAN WEARING A HAT

5
NICOLAS NEUCHATEL, called LUCIDEL
(1527-1590?)

HEAD OF A BEARDED MAN
*Black chalk, with a few touches of white bodycolour
and some pale brown wash on the beard. 285:199*

1936-10-10-25

6
LUCAS VAN LEYDEN
(1494-1538)

AN OLD MAN, WRITING OR DRAWING
Black chalk. 272:273
Signed lower right: 'L'.

1892-8-4-16

7
LUCAS CRANACH I
(1472-1553)

HEAD OF A MAN WEARING A HAT
*Pen and black ink and brown, black and red wash, and
white bodycolour. 267:187*

1896-5-11-1

8
HANS HOLBEIN I
(1460/1465-1524)

SIGMUND HOLBEIN
*Metalpoint on cream-coloured paper, touched with red
chalk and white bodycolour. 129:95*
Inscribed by the draughtsman: *1512 Sigmund
holbain maler Hans pruder des alten.*

4
LUCAS VAN LEYDEN
(1494-1538)

A YOUNG MAN WEARING A HAT
Black chalk. 205:164
Signed lower left: 'L'.

1892-8-4-11

Sigmund Holbein (d. 1540), painter, younger brother of, and collaborator with, Hans Holbein the Elder.

Collections: Lawrence, Robinson, Malcolm
1895-9-15-987

9
HANS BURGKMAIR
(c. 1473-1553 or 9)

HEAD OF A MAN IN A CAP
Black chalk. 312:221

5218-28, bequeathed by Sir Hans Sloane in 1753

10
HEINRICH ALDEGREVER
(1502-c. 1558)

JOHN OF LEYDEN
Black chalk, touched with red chalk on the face and lips. The figure has been cut out and mounted on another sheet. 275:233

Jan Bockelson (1510-1536), called Jan van Leiden, leader of the Anabaptists, an heretical sect of extreme protestants who denied the validity of infant baptism. He established a popular theocracy in Münster in Westphalia, claiming for himself royal honours, as the successor of King David. The drawing is a study for an engraving, dated 1536, showing him in his regalia.

1886-6-9-38

11
Attributed to PETER GÄRTNER
(fl. 1530-39)

FRIEDRICH OF BRANDENBURG
Pen and brown ink with oil colour on the face, beard and hair. 398:303

Friedrich, Markgraf of Brandenburg-Ansbach (1460-1536), succeeded his father 1486, deposed by his sons 1515.

1949-4-11-111, bequeathed by Campbell Dodgson

12
GEORG PENCZ
(fl. 1500-1550)

HEAD OF A YOUNG MAN
Black ink and black, red and brown chalk. 246:174
Signed top centre with monogram.

1884-7-26-26

13
Attributed to JAN VAN SCOREL
(1495-1562)

HEAD AND SHOULDERS OF A YOUNG WOMAN
Red chalk. 286:195

The attribution to Scorel is conjectural. The name of his pupil Antonio Mor (1519-1575/6) has also been suggested.

1895-9-15-995
Transparency PD 1

14
ALBRECHT DÜRER
(1471-1528)

A YOUNG MAN WEARING A HAT
Black chalk. 375:267

Inscribed in ink, top r. (not by Dürer), with his monogram and the date 1521: presumably a transcription of a genuine monogram and date formerly at the top of the sheet, but trimmed off. The lower part of the original date, in black chalk, can be seen immediately above the transcription.

5218-54, bequeathed by Sir Hans Sloane in 1743

11 Attributed to PETER GÄRTNER
FRIEDRICH OF BRANDENBURG

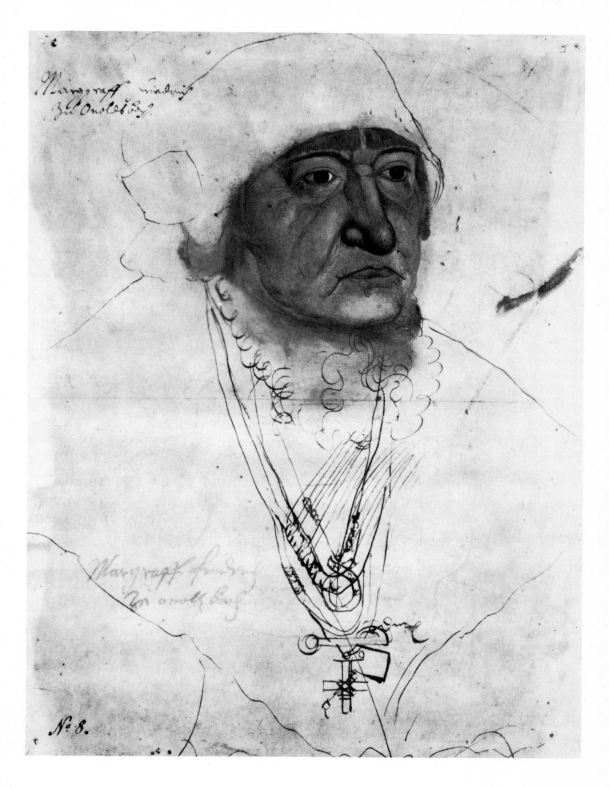

15
ALBRECHT DÜRER
(1471-1528)

HEAD OF A MAN (PAULUS HOFHAIMER?)
Brown and black chalk. 370:275

It has been suggested with some plausibility that the drawing represents Paulus Hofhaimer (1459-1537), organist to the Emperor Maximilian, whom Dürer could have met in Augsburg in 1518. The style of the drawing suggests a dating about that time.

5218-52, bequeathed by Sir Hans Sloane in 1753

16
ALBRECHT DÜRER
(1471-1528)

LORD MORLEY
Black chalk on green prepared paper. 377:305

Henry Parker, 8th Lord Morley (1476-1556), writer and courtier. The drawing was presumably made in Nuremberg in 1523, where Morley was undertaking a diplomatic mission.

1890-5-12-155

17
ALBRECHT DÜRER
(1471-1528)

A YOUNG MAN WEARING A HAT
Black chalk. 368:255
Inscribed with a false signature of Lucas van Leyden.

Collection: Warwick
1910-2-12-103, bequeathed by George Salting

18
ALBRECHT DÜRER
(1471-1528)

A WINDISH PEASANT WOMAN
Pen and brown ink, and brown wash in the background. 415:283
Signed with monogram and dated, *1505*. Inscribed: *Vna vilana Windisch.*

The Windish Mark was in Carinthia, in Southern Austria. Dürer probably made this drawing when *en route* for Venice, at the beginning of his second visit to Italy.

1930-3-24-1

19
ALBRECHT DÜRER
(1471-1528)

ULRICH STARCK
Black chalk. 407:297
Signed with monogram and dated, *1527.*

Ulrich Starck (1484-1549), a rich Patrician of Nuremberg.

5218-51, bequeathed by Sir Hans Sloane in 1753

20
ALBRECHT DÜRER
(1471-1528)

HEAD OF A YOUNG MAN WEARING A HAT, LOOKING TO LEFT
Black chalk. 416:227
Signed with monogram and dated, *1516.*

5218-44, bequeathed by Sir Hans Sloane in 1753

21
ALBRECHT DÜRER
(1471-1528)

CONRAD MERKEL
Black chalk. Touches of brown wash on chin and right cheek. 295:219
Inscribed: *Hÿe Conrad Verkell altag* and dated, *1508.*

The drawing probably represents Conrad Merkel,

a painter of Ulm with whom Dürer had some correspondence in 1510. The changed spelling of his name in the inscription has been ingeniously explained as a punning change to match his facial appearance (*Verkell = Ferkel* = pig). Following this suggestion, the inscription has been translated: 'with me it's always Conrad Hog'.

5218-27, bequeathed by Sir Hans Sloane in 1753
Transparency PD 2

22
ALBRECHT DÜRER
(1471-1528)

HEAD OF A MAN
Charcoal. 296:187
Signed with monogram and dated, *1505*.

1895-9-15-984

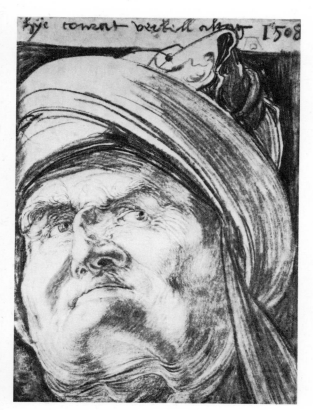

23
ALBRECHT DÜRER
(1471-1528)

HEAD OF A MAN IN PROFILE TO LEFT
Pen and brown ink. 208:148
Dated, *1505*.

5218-31, bequeathed by Sir Hans Sloane in 1753

24
BENVENUTO TISI, called IL GAROFALO
(c. 1481-1559)

HEAD OF A YOUNG MAN
Black chalk. 281:263

Collections: Lely, Malcolm
1895-9-15-770
Transparency PD 3

25
NORTH ITALIAN (LOMBARD?)
(c. 1500)

HEAD AND SHOULDERS OF A BEARDED MAN
Oil on paper. 387:274

5218-46, bequeathed by Sir Hans Sloane in 1753

26
VENETIAN SCHOOL
(c. 1500)

HEAD AND SHOULDERS OF A BEARDED MAN
Black chalk on pale brown paper. 399:314

The names of Bonsignori, Filippo Mazzola and Marziale have been suggested; but the facial type and sense of plasticity point rather to Cristoforo Caselli (fl. 1488-d. 1521).

5218-47, bequeathed by Sir Hans Sloane in 1753

21 ALBRECHT DÜRER
CONRAD MERKEL

27
BERNARDINO LUINI
(c. 1475-1531/2)

BIAGIO ARCHIMBOLDI
Black chalk. 236:147
Signed and inscribed: *Blasij Arcimboldi Pictoris imago.*

The inscription describes Archimboldi as a painter, but he is not elsewhere recorded and no work by him is known.

Collection: Malcolm
1895-9-15-767

28
LORENZO LOTTO
(1480-1556)

HEAD OF A MAN WEARING A CAP
Black chalk and grey wash. 269:195

An early drawing, showing the influence of Lotto's master Alvise Vivarini.

1902-8-22-2

29
PADUAN SCHOOL
(c. 1450-1475)

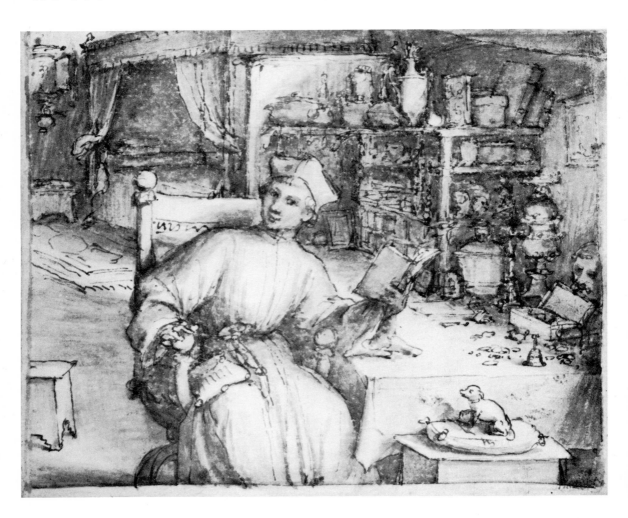

PROFILE OF A YOUTH
Pen and brown wash. 247:169

Close in style to Marco Zoppo (c. 1433-1478)

Collection: Malcolm
1895-9-15-778

30
VITTORE CARPACCIO
(c. 1455-1526)

HEAD OF A MIDDLE-AGED MAN
Brush-drawing in brown wash over black chalk, heightened with white, on blue paper. 266:185

Datable in the first decade of the sixteenth century.

1892-4-11-1

31
LORENZO LOTTO
(1480-1556)

A YOUTHFUL ECCLESIASTIC IN HIS STUDY
Pen and brown wash, heightened with white. 162:198

Datable c. 1540.

Collection: Phillipps-Fenwick
1951-2-8-34, presented anonymously
Transparency PD 4

32
Attributed to GIOVANNI BELLINI
(1430?-1516)

HEAD AND SHOULDERS OF A MAN AND TWO WOMEN
Black chalk. 143:200 (size of original sheet 130:200)

Though obviously inspired by an Antique Roman sepulchral sculpture, the head of the man is so intensely and individually characterized as to

bring it within the definition of a portrait.

1900-7-17-31

33
RAPHAEL
(1483-1520)

A YOUNG WOMAN
Black chalk. 259:183

Datable in Raphael's Florentine period, c. 1505-8.

Collections: Ottley, Lawrence, King William II of Holland, Wellesley, Malcolm
1895-9-15-613
Transparency PD 5

34
LORENZO DI CREDI
(1456/9-1537)

HEAD OF A BOY
Metalpoint, heightened with white, on pale brown prepared paper. The outlines indented. 231:199

Collections: Richardson, Lawrence, Malcolm
1895-9-15-460

35
RAPHAEL
(1483-1520)

HEAD OF A MAN
Black chalk over stylus underdrawing: 255:190

The purpose of the drawing is unknown. It may have been made as a study for a head in a painting. Datable c. 1504, on the strength of its resemblance to some of the heads in the Brera *Sposalizio*.

Collections: Houlditch, Lawrence, King William II of Holland, Malcolm
1895-9-15-619

31 LORENZO LOTTO
A YOUTHFUL ECCLESIASTIC IN HIS STUDY

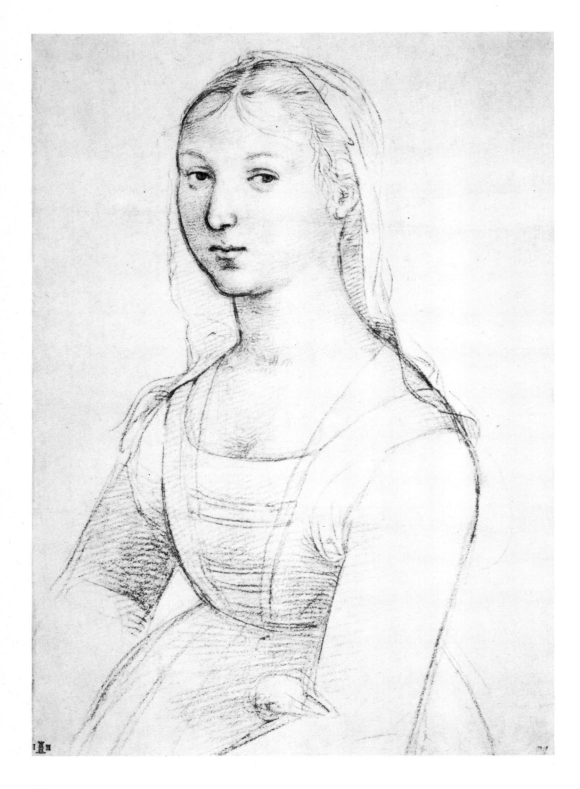

36
Attributed to FRANCESCO DA SAN GALLO
(1494-1576)

HEAD OF AN OLD MAN (LEONARDO BUONAFEDE?)
Red chalk on pale brown paper. 265:320

The attribution to Francesco da San Gallo is based on the striking resemblance between this profile and that of his recumbent effigy of Leonardo Buonafede, Bishop of Cortona (d. 1545), in the Certosa near Florence.

Collections: Lawrence, Phillipps-Fenwick
1946-7-13-5, presented by the National Art-Collections Fund

33 RAPHAEL
A YOUNG WOMAN

36 Attributed to FRANCESCO DA SAN GALLO
HEAD OF AN OLD MAN (LEONARDO BUONAFEDE?)

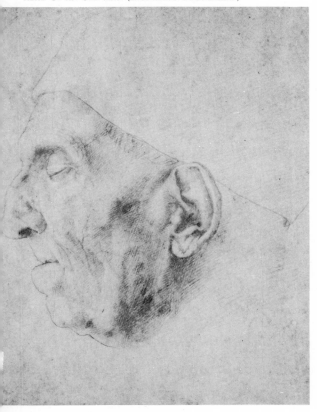

37
DOMENICO GHIRLANDAIO
(c. 1449-1494)

HEAD OF AN ELDERLY MAN IN PROFILE
Metalpoint, heightened with white, on pink prepared paper. 166:130

Pp. 1-3, bequeathed by Richard Payne Knight in 1824
Transparency PD 6

38
DOMENICO GHIRLANDAIO
(c. 1449-1494)

A YOUNG WOMAN, HALF-LENGTH
Metalpoint and faint wash, heightened with white, on grey prepared paper. 320:216

Collection: Richardson
Pp. 1-27, bequeathed by Richard Payne Knight in 1824

39
CARLETTO CALIARI
(1570-1596)

PAOLO PARUTA
Black, red and white chalk on blue paper. 294:195

Paolo Paruta (1540-1598), Venetian diplomatist and historian, Historiographer to the Republic of Venice. The drawing was for a time attributed to Leandro Bassano, but the traditional attribution to Carletto Caliari seems more likely to be correct.

Collections: Sagredo, Richardson, Lawrence, Phillipps-Fenwick
1946-7-13-23, presented anonymously

40
Attributed to GIULIO CAMPI
(1500/2-1572)

HEAD OF A LADY IN PROFILE
Red chalk. 147:122

Various attributions (Pordenone; Bernardino Licinio; Girolamo Giovenone) have been suggested, but that to Giulio Campi seems the most probable.

Collection: Malcolm
1895-9-15-821

41
FRANCESCO DI CRISTOFANO, called FRANCIABIGIO
(1482-1525)

HEAD OF A MAN IN PROFILE
Black chalk on buff paper. 240:173

1890-4-15-174

42
DOMENICO BECCAFUMI
(1485-1551)

(a) HEAD OF A BEARDED MAN
Oil on paper. 203:145

(b) HEAD OF A WOMAN
Oil on paper. 194:130

1953-12-12-3 and 4

43
BALDASSARE PERUZZI
(1481-1536)

STUDY FOR A PORTRAIT OF A WOMAN WITH TWO MEN
Pen and brown ink. 234:217

Presumably an idea for a Giorgionesque portrait of a courtesan and two lovers. The style suggests a date c. 1511, when Peruzzi was in close contact with the Venetian Sebastiano del Piombo.

Collection: Hugh Howard
1874-8-8-32

44
Attributed to BACCIO BANDINELLI
(1493-1560)

HALF-LENGTH PORTRAIT OF A LADY
Red chalk. 240:163

Collection: Malcolm
1895-9-15-544

45
MICHELANGELO
(1475-1564)

ANDREA QUARATESI
Black chalk. 210:291

Andrea Quaratesi (1512-1585), a member of a noble Florentine family and one of Michelangelo's intimate friends. The style of the drawing and the apparent age of the sitter suggest a date c. 1530 for the drawing. No other finished portrait drawing by Michelangelo is known.

Collections: Wellesley, Malcolm
1895-9-15-519

46
SEBASTIANO DEL PIOMBO
(c. 1485-1547)

ANTONIO SALAMANCA
Black chalk. 225:164

Antonio Salamanca (c. 1500-1562), Roman engraver, publisher and printseller. The engraved portrait of him by Nicolas Beatrizet (B. xv, p.243, 6) is clearly of the same man at a later age.

Collections: Mariette, Fries, Lagoy, Lawrence
1860-6-16-80

45 MICHELANGELO
ANDREA QUARATESI

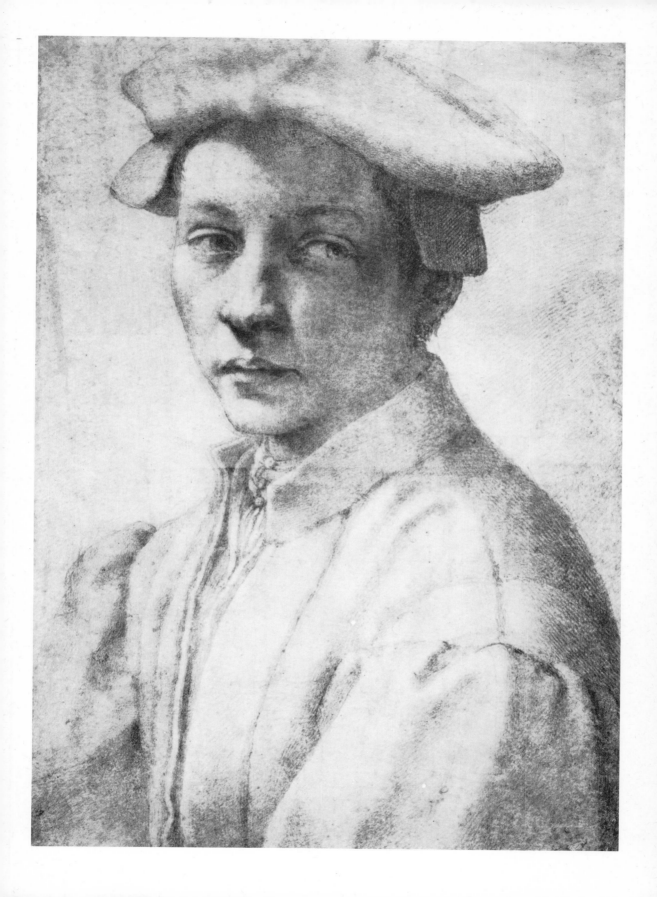

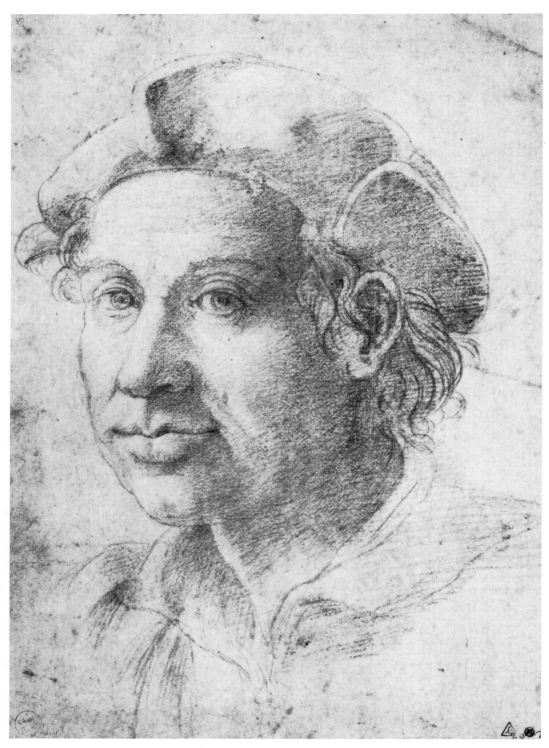

46 SEBASTIANO DEL PIOMBO
ANTONIO SALAMANCA

47
ALESSANDRO ALLORI
(1535–1607)

HEAD AND SHOULDERS OF A BOY
Black and white chalk. 336:245

1876-7-8-2389

48
SEBASTIANO DEL PIOMBO
(c. 1485–1547)

POPE CLEMENT VII AND THE EMPEROR CHARLES V
Black and white chalk on grey-washed paper. 311:463

The Pope and Emperor are seated in council with their advisers, the divine basis of their authority being symbolized by the monstrance placed between the tiara and the crown. It probably dates from soon after their meeting and reconciliation in Bologna in 1530.

1955-2-12-1, presented by the National Art-Collections Fund (Campbell Dodgson Bequest)

49
AGNOLO ALLORI, called BRONZINO
(1502?–1572)

STUDY FOR A PORTRAIT OF A GENTLEMAN
Black chalk. 393:247

Collections: Skippe, Rayner-Wood
1958-12-13-1, presented jointly by the Holland-Martin family and the National Art-Collections Fund

50
Attributed to JEAN CLOUET
(c. 1486–1541)

JACQUES RICARD
Black and red chalk. 264:197

Jacques Ricard, called Galiot, seigneur of Assier en Quercy (1465–1546). The drawing is datable c. 1515. A later portrait of him is at Chantilly.

1910-2-12-83, bequeathed by George Salting

51
Attributed to JEAN CLOUET
(c. 1486–1541)

GUILLAUME DE SAULX, SIEUR DE TAVENNES
Black and red chalk. 245:191
Datable c. 1529

1910-2-12-54, bequeathed by George Salting

52
HANS HOLBEIN II
(1497–1543)

AN ENGLISH LADY
Black chalk, heightened with white, and with touches of red chalk and yellow watercolour, on pink prepared paper. Roughly silhouetted round the outline of the figure and stuck onto a sheet of pink-washed paper. 227:193

The traditional identification of the sitter as Margaret Roper, Sir Thomas More's daughter, is almost certainly incorrect.

Collections: Richardson, Lord Ronald Gower

1910-2-12-105, bequeathed by George Salting

53
FEDERICO ZUCCARO
(1540/1–1609)

QUEEN ELIZABETH I
Black and red chalk. 309:221
Dated on *verso: magio* 1575.

Federico Zuccaro came to England in March 1575 at the request of Queen Elizabeth's favourite, Robert Dudley, Earl of Leicester, in order to paint her portrait and his. No painting of the Queen is known or recorded, but the companion drawing of Leicester served as basis for a portrait formerly in the collection of the Dukes of Sutherland (destroyed by enemy action in 1940). To judge from

53 FEDERICO ZUCCARO
QUEEN ELIZABETH I

54
FEDERICO ZUCCARO
(1540/1-1609)

THE EARL OF LEICESTER
Black and red chalk. 325:220
See no. 53.
Collection: Duke of Argyll
Gg. 1-418, bequeathed by the Rev. C. M. Crache-
rode in 1799

55
BERNARDINO BARBATELLI, called POCCETTI
(c. 1545-1612)

A YOUNG MAN
Black and white chalk. 188:163
Inscribed near lower edge: *A Caracci.*
1853-8-13-26

56
FEDERICO BAROCCI
(1526-1612)

HEAD OF A BEARDED MAN
*Charcoal, with red, yellow and white chalk and pink
pastel, on (faded) blue paper.* 392:293
Inscribed lower right: *Barocci.*

Possibly a portrait of Barocci's patron, Francesco
Maria II Duke of Urbino (1574-1631).
1897-4-10-8

a photograph, this painting was probably not
from Federico's own hand.

Federico's visit to England was responsible for
the attribution to him not only of many portraits
of Queen Elizabeth but of innumerable late
sixteenth-century portraits in country house
collections.

Collection: Duke of Argyll
Gg. 1-417, bequeathed by the Rev. C. M. Crache-
rode in 1799

57
FRANCESCO PRIMATICCIO
(1504-1570)

HEAD OF A BEARDED MAN
*Black chalk, heightened with white, on pale brown
paper.* 145:106

Apparently drawn from a death-mask. The feat-
ures closely resemble those of King Henri II of
France (1547-1559), for whom Primaticcio

worked at Fontainebleau.

Collections: Udney, Lawrence, Phillipps-Fenwick
1946-7-13-486, presented anonymously
Transparency PD 7

58
FEDERICO ZUCCARO
(1540/1-1609)

HALF-LENGTH OF A BEARDED MAN IN PROFILE TO
RIGHT
Black and red chalk and greyish-brown wash. 199:157

Collection: Lempereur

Pp. 3-216, bequeathed by Richard Payne Knight
in 1824

59
NORTH ITALIAN SCHOOL (LOMBARD OR EMILIAN), mid-sixteenth century

HEAD OF A BOY
Black chalk. 163:131
Inscribed top right: *Procacino.*

Collections: Lely, Lawrence, Phillipps-Fenwick
1946-7-13-494, presented anonymously

57 FRANCESCO PRIMATICCIO
HEAD OF A BEARDED MAN

60
Attributed to FRANS POURBUS I
(1545-1581)

HEAD OF AN ELDERLY LADY
*Black and red chalk, with brown wash on the hair and
eyes.* 200:176

The costume suggests a date towards the end of
the artist's life.

Oo. 9-6, bequeathed by Richard Payne Knight in
1824

61
JACOB de GHEYN II
(1565-1629)

A GENTLEMAN STANDING BY THE DEATH-BED OF A
LADY
Watercolour on vellum. 208-287
Signed and dated, *1601.*

The features of the man closely resemble those of
de Gheyn himself, as they appear in the engraving
published in 1610 by Hendrick Hondius. If this is
a self-portrait, then the dead lady is presumably
his wife, Eva Stalpaert, whom he married in 1595

and who is known to have been dead by 1613. She made her Will in 1599.

Collection: Malcolm
1895-9-15-1020

62
HENDRICK GOLTZIUS
(1588-1617)

(a) THREE STUDIES OF THE HEAD OF A GENTLEMAN WEARING A WIDE-BRIMMED HAT
Metalpoint on cream-coloured prepared surface (vellum?). 147:131
Signed with monogram.

(b) THE HEAD OF A YOUNG MAN AND TWO HANDS
Metalpoint on cream-coloured prepared surface (vellum?). 69:100

Collection: Malcolm
1895-9-15-1021 and 1022

63
HENDRICK GOLTZIUS
(1558-1617)

(a) A THREE-YEAR-OLD BOY
Pen and brown ink touched with red and black chalk. 176:99
Signed with monogram and dated, 1594, and inscribed *Aetat 3.*

(b) A FIVE-YEAR-OLD GIRL
Pen and brown ink touched with red and black chalk. 175:111
Signed with monogram and dated, *1594,* and inscribed *Aetat 5.*

Collections: Lawrence, Phillipps-Fenwick
1946-7-13-156 and 157, presented anonymously

64
AMBROGIO FIGINO
(1550-after 1595)

(a) ST CARLO BORROMMEO ALIVE
Red and white chalk. 165:95

(b) ST CARLO BORROMMEO DEAD
Red chalk. 164:94

Carlo Borrommeo (1538-1584), Cardinal-Archbishop of Milan, 1560. Canonized 1610.

The inscriptions, in the hand of the Milanese collector and connoisseur, Padre Sebastiano Resta, record that he removed both drawings from a book of studies by Figino which was for sale in Rome in 1700.

1896-12-15-4 and 5

65
FRANCESCO VILLAMENA
(1566-1624)

GIOVANNI RIDOLFO ALTO
Black and red chalk. 348:517
Inscribed (by Padre Resta) near lower edge: *pare che dica sig[no]ri in Roma Io Franc° Villamena servij i Pittori di questo Tempo.*

A preparatory drawing for an engraving, dedicated by Villamena to Cassiano del Pozzo and dated 1623. Alto is described as 'Miles praetorianus, romanorum antiquitatum indagator monstratorque'. He was evidently well-known as a guide and 'cicerone'. In the drawing he is shown standing outside the Palazzo del Quirinale, with a prospect of Rome in the background.

Collection: Resta
1860-4-14-1

62a HENDRICK GOLTZIUS
THREE STUDIES OF THE HEAD OF A GENTLEMAN

XVII CENTURY: MOSTLY ITALIAN

66
SIMON VOUET
(1590-1649)

ALESSANDRO TASSONI
Black and red chalk. 119:87
Inscribed on *verso: Alexander Tassonus Poeta Simon Voet Gallus ad Vi[v]um effigiavit.*

Alessandro Tassoni (1565-1635), satirical poet.

1846-7-9-16

67
BOLOGNESE SCHOOL, Ist half of the XVII century

HEAD OF A YOUNG MAN
Black chalk, touched with white chalk, on grey paper. 375:270

Collection: Phillipps-Fenwick
1946-7-13-743, presented anonymously

68
CARLO DOLCI
(1616-1686)

HEAD OF A BENEDICTINE MONK
Black and red chalk. 169:114

Collection: Spencer
Pp. 5-111, bequeathed by Richard Payne Knight in 1824.

69
CIRO FERRI
(1634-1689)

PORTRAIT OF A BEARDED MAN

Brush-drawing in brown wash, heightened with white, on brownish-grey paper. The outlines incised: 210:166
Signed, and inscribed *Incidatur. Fr. Frans Mandarini Rmi P. SS. P.M. Soc*

A design for an engraving. Mandarini was the ecclesiastical censor who approved the publication of the engraving with the word 'Incidatur' ('let it be engraved).

Collections: Lawrence, Phillipps-Fenwick
1946-7-13-751, presented anonymously

70
BOLOGNESE (?) SCHOOL, early seventeenth century

(a) HEAD OF A BOY, WEARING A HAT
Red chalk. 103:93

(b) HEAD AND SHOULDERS OF A BOY WEARING A HAT
Red chalk. 134:95

1946-7-8-1 and 2, presented by Sir Anthony Blunt

71
SALVATOR ROSA
(1615-1673)

HEAD OF A MAN IN PROFILE
Pen and brown ink over red chalk. 135:125

Collection: Hudson
Ff. 2-166, bequeathed by the Rev. C. M. Cracherode in 1799.

72
OTTAVIO LEONI
(1587-1630)

POPE GREGORY XV
Black, red and white chalk on blue paper. 232:159
Numbered *182*, and dated February 1621.

Gregory XV (Ludovisi) was elected Pope on
9 February 1621 and died in 1623.

1860-7-14-31

73
OTTAVIO LEONI
(1587-1630)

A YOUNG LADY PLAYING A LUTE
*Black chalk touched with white bodycolour on faded
blue paper.* 207:141

Collection: Malcolm
1895-9-15-661

74
OTTAVIO LEONI
(1587-1630)

A YOUNG MAN WEARING A RUFF
Black, red and white chalk on blue paper. 228:157
Numbered *167*, and dated September 1620.

1860-7-14-34

75
OTTAVIO LEONI

A YOUNG MAN WITH A BEARD
Black, red and white chalk on blue paper. 231:154
Numbered *401* and dated July 1628.

1854-6-28-87

76
JUAN CARREÑO de MIRANDA
(1614-1685)

A COURT DWARF
*Black chalk with touches of red chalk on the face and
hands.* 269:161

1850-7-13-6

77
CRISTOFANO ALLORI
(1577-1621)

A BEARDED MAN
Black, red and white chalk on blue paper. 208:153

On entering the collection, and until very recently,
considered to be a portrait of Cristofano Allori by
Ottavio Leoni. The style and handling are quite
uncharacteristic of Leoni, but come very close to
Allori's. The most likely explanation of the con-
fusion is that the drawing was once inscribed with
an old attribution to Allori, but was mistakenly
given to Leoni on the strength of its superficial
resemblance, in scale and in the colour of the
paper, to drawings by him.

1854-6-28-86

78
SIMONE CANTARINI
(1612-1648)

HEAD OF A YOUNG MAN
Black and red chalk on brown paper. 169:145

1858-11-13-69

79
FRANCISCO ZURBURAN
(1598-1664)

HEAD OF A MONK WITH CLOSED EYES
Black chalk. 277:196

One of the very few drawings attributable with any certainty to Zurburan. It has been suggested that it may have been made in connexion with his painting, now in the Louvre, of *St Bonaventura on his Bier,* though the head is there seen from the side.

Collections: Madrazo, Malcolm
1895-9-15-873

80
AGOSTINO CARRACCI
(1557-1602)

POPE CLEMENT VIII
Pen and brown ink. 144:120

Clement VIII Aldobrandini (1592-1605). The drawing was previously attributed to Annibale Carracci, but the scratchy handling is more characteristic of Agostino.

Collection: Malcolm
1895-9-15-695

81
GUIDO RENI
(1575-1642)

AN OLD MAN SEATED, WEARING A CLOAK AND HOLDING HIS HAT
Red chalk. 219:180

Collection: Malcolm
1895-9-15-700

82
OTTAVIO VANNINI
(1585-1643)

A MAN WRITING AT A TABLE
Red chalk with touches of white chalk on blue paper. 319:231

1928-4-12-1, presented by R. Ward

83
GIOVANNI FRANCESCO BARBIERI, called IL GUERCINO
(1591-1666)

A YOUNG MAN, HALF-LENGTH, IN PROFILE TO LEFT
Red chalk. 188:160

1953-4-11-48, bequeathed by E. H. W. Meyerstein

84
GIACOMO CAVEDONE
(1577-1660)

HEAD OF A BOY
Black chalk on pale brown paper. 402:277

Collections: Lawrence, Phillipps-Fenwick
1946-7-13-83, presented anonymously
Transparency PD 8

XVII CENTURY: FLEMISH & DUTCH

85
PETER PAUL RUBENS
(1577-1640)

SIR THEODORE MAYERNE
Black chalk and grey wash, with oil-colour on the head and beard. 312:219

Sir Theodore Turquet de Mayerne (1573-1655), physician to King Henri IV of France. Came to England in 1611, where he was physician to James I and Charles I. A study for the portrait now in the National Portrait Gallery.

Collection: Lawrence
1860-6-16-36
Transparency PD 47

86
PETER PAUL RUBENS
(1577-1640)

PETER VAN HECKE
Black chalk. 414:345

Peter van Hecke was the husband of Rubens's sister-in-law, Clara Fourment.

Collections: Richardson, Hudson, Thane, Cosway, W. Russell
1895-5-9-48
Transparency PD 48

87
PETER PAUL RUBENS
(1577-1640)

JUSTUS LIPSIUS
Black chalk and pen and brown ink. 230:185

Justus Lipsius (1547-1606), Flemish scholar and jurist. The drawing was made for the engraving in reverse by Philip Galle which served as frontispiece to Lipsius's edition of Seneca (Antwerp 1615).

1891-5-11-31

88
PETER PAUL RUBENS
(1577-1640)

ISABELLA BRANT
Black, red and white chalk. 382:294

The artist's first wife, whom he married in 1609 and who died in 1626.

Collections: Lankrinck, Richardson, Thornhill, Spencer
1893-7-31-21
Transparency PD 49

89
PETER PAUL RUBENS
(1577-1640)

MARIE DE MEDICIS
Pen and brown wash. 65:38

Marie de Medicis, Queen of France (1575-1642), wife of King Henry IV. One of Rubens's patrons, for whom he executed, between 1622 and 1625, a series of large paintings of the events in her life (now in the Louvre).

Oo. 9-21, bequeathed by Richard Payne Knight in 1824.

85 PETER PAUL RUBENS
SIR THEODORE MAYERNE

90
PETER PAUL RUBENS
(1577-1640)

HENDRICK VAN THULDEN
Black chalk. 374:261 (top corners cut)

Hendrick van Thulden (d. 1645), Professor of Jurisprudence at the University of Louvain. A study for the portrait in Munich (c. 1615-16).

Collections: Richardson, Hudson, Reynolds
1845-12-8-5

91
PETER PAUL RUBENS
(1577-1640)

HELENA FOURMENT
Black chalk, heightened with white, on buff paper.
430:260

The artist's second wife, whom he married in 1630. A study either for the full-length portrait with her son Frans, in the Rothschild Collection, or for the half-length one in Munich.

1882-6-10-96, presented by J. Deffett Francis

92
PETER PAUL RUBENS
(1577-1640)

FRANS RUBENS
Red and black chalk. 200:149

Rubens's son by his second wife, Helena Fourment. A study for the painting of *Helena Fourment with her Son* in Munich (c. 1635).

Collections: Richardson, Hudson, Malcolm
1895-9-15-1047

93
ANTHONIE VAN DYCK
(1599-1641)

HENRI DUPUIS (ERYCIUS PUTEANUS)

Black chalk and brown wash. 245:169
Signed and dated, *1646.*

Henri Dupuis (1574-1646), better known by the Latinized form of his name: scholar, Professor of Latin at the University of Louvain. A study for the engraving in reverse by Pieter de Jode II in the *Iconography.*

Collections: Hudson, Malcolm
1895-9-15-1069

94
ANTHONIE VAN DYCK
(1599-1641)

NICOLAS ROCKOX
Pen and brown wash over black chalk. 193:162. Oval.

Nicolas Rockox (1560-1640), Burgomaster of Antwerp. Very close to the head in the portrait of 1621-22, formerly in the Lederer Collection, Budapest; but the drawing looks more like a preparatory study for an engraving.

Collection: Malcolm
1895-9-15-1068

95
ANTHONIE VAN DYCK
(1599-1641)

JAN WILDENS
Black chalk and grey and brown wash. 236:200

A study for the engraving in reverse by Paulus Pontius in the *Iconography.*

1925-7-11-2, presented by G. W. Duffett
Transparency PD 50

96
ANTHONIE VAN DYCK
(1599-1641)

HUBERT VAN DEN EYNDEN
Black chalk and grey wash. 226:159

Hubert van den Eynden (fl. 1620 onwards, d. 1661), sculptor. A study for the engraving by Lucas Vorsterman in the *Iconography*.

Collections: Mariette, Lawrence
1900-8-24-141, bequeathed by Henry Vaughan

97
ANTHONIE VAN DYCK
(1599-1641)

ORAZIO GENTILESCHI
Black chalk, with some grey wash and a few touches of pen and brown ink. The outlines indented for transfer.
238:178

Orazio Gentileschi (1552-1647), painter. Born in Pisa, worked in Rome and Paris and in London (where he was brought in 1626 by the Duke of Buckingham) for King Charles I.

A study for the engraving in reverse by Lucas Vorsterman in the *Iconography*.

Collection: T. Hudson

Gg 2-238, bequeathed by the Rev. C. M. Cracherode in 1799

95 ANTHONIE VAN DYCK
JAN WILDENS

98
ANTHONIE VAN DYCK
(1599-1641)

SEBASTIAN VRANCX
Black chalk. 256:186

Sebastian Vrancx (1573-1647), painter and Rubens's fellow pupil in the studio of Adam van Noort. A study for the engraving by S. à Bolswert in the *Iconography*.

Collection: Malcolm
1895-9-15-1073

99
ANTHONIE VAN DYCK
(1599-1641)

ERNESTINA, COUNTESS OF NASSAU-SIEGEN, AND HER SON, FRANCIS DESIDERATUS OF NASSAU-SIEGEN
Black chalk, heightened with white, on greenish-grey paper. 440:280

Collection: H. Howard
1874-8-8-139

100
LUCAS VORSTERMAN
(1595-1675)

SIR FRANCIS CRANE
Black and red chalk. 178:140
Inscribed: *S^r Francisco Craen Secret. del ord. di St. Gorge et M^e de Tapisserij.*

Sir Francis Crane (d. 1636), Chancellor of the Order of the Garter and director of the tapestry works at Mortlake.

Collection: J. Thane
1849-3-28-3

101
ANTHONIE VAN DYCK
(1599-1641)

THE EARL OF ARUNDEL
Black chalk, heightened with white, on grey-green paper. 480:355

Thomas Howard, Earl of Arundel (1585-1646), grandson and heir of the 4th Duke of Norfolk, attainted for High Treason in 1572, and grandfather of the 5th Duke. A distinguished collector, described by Walpole as 'the father of Vertu in England'. No painting corresponding with this drawing is known.

1854-5-13-16

102
ANTHONIE VAN DYCK
(1599-1641)

A LADY STANDING
Pen and brown ink and grey wash. 295:157

Collections: Vindé, Dimsdale, Lawrence
1900-8-24-142, bequeathed by Henry Vaughan
Transparency PD 51

103
ANTHONIE VAN DYCK
(1599-1641)

THE DUKE OF RICHMOND
Black chalk, heightened with white, on pale brown paper. 295:157

James Stuart (1612-1655), 4th Duke of Lennox and 1st Duke of Richmond. A cousin of Charles I. The drawing is a study for the painting now in the Metropolitan Museum of Art, New York.

Collection: H. Howard
1874-8-8-142

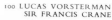
100 LUCAS VORSTERMAN
SIR FRANCIS CRANE

104
JAN COSSIERS
(1600-1671)

HEAD AND SHOULDERS OF A YOUTH (JACOBUS COSSIERS?)
Black, red and yellow chalk, and grey and brown wash.
271:202
Inscribed: *Jacobus Cossiers 1658.*

Oo. 10-179, bequeathed by Richard Payne Knight in 1824.

105
REMBRANDT
(1606-1669)

JAN CORNELIS SYLVIUS
Pen and brown wash, heightened with white. 282:193

Jan Cornelis Sylvius (1564-1638), preacher, and cousin and guardian of Rembrandt's wife Saskia. A study for the etching, dated 1646.

Collection: Hugh Howard
1874-8-8-2272

106
REMBRANDT
(1606-1669)

CORNELIS CLAESZ ANSLO
Red chalk, heightened with white. The outlines indented for transfer. 157:144
Signed and dated, *1640.*

Cornelis Claesz Anslo (1592-1646), theologian and Mennonite minister. A study for the etching, dated 1641.

Collections: Goll van Franckenstein, Aylesford
1848-9-11-138

107
REMBRANDT
(1606-1669)

A LADY HOLDING A FAN

Pen and brown wash heightened with white, with a few touches of red chalk. 160:129

A study for the painting known as the *Femme d'Utrecht,* dated 1639.

Collections: Lawrence, Esdaile
1891-7-13-9

108
REMBRANDT
(1606-1669)

A LADY IN AN ARMCHAIR (HENDRIJKE STOFFELS?)
Reed pen and brown ink. 163:144

The costume suggests that this is a study for a fancy portrait of a lady in sixteenth-century dress, though no such picture is known.

1948-7-10-7, purchased with help from the National Art-Collections Fund and an anonymous donor
Transparency PD 61

109
GERARD DOU
(1613-1675)

AN OLD WOMAN
Black and red chalk. 168:130
Signed.

1891-5-11-30

110
PIETER DU BORDIEU
(1609/10-after 1677)

PORTRAIT OF A GENTLEMAN
Oil (grisaille) on canvas. 138:102

1890-10-13-6

111
JAN LIEVENS
(1607-1674)

ADMIRAL TROMP

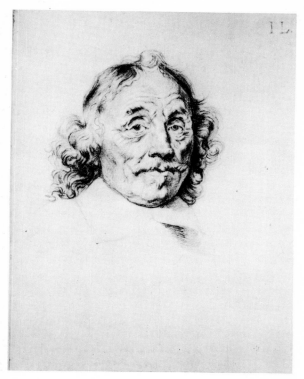

III JAN LIEVENS
ADMIRAL TROMP

Black chalk. 235:180

Maerten Tromp (1597-1653), Admiral, commanded the Dutch fleet in the naval war against England. Probably a study for the portrait in the Rijksmuseum, Amsterdam.

Collections: Ploos van Amstel, Sheepshanks
1836-8-11-344
Transparency PD 62

112
By, or after, JAN DE BRAY
(c. 1627-1697)

THE REGENTS OF THE ORPHANAGE AT HAARLEM
Pen and brown ink and grey wash. 229:301

Signed and dated, *1663.*

The drawing corresponds closely with a painting in the gallery at Haarlem, but it has been suggested that it is not a preliminary study but a copy by Ploos van Amstel after a lost original. It is included as an example of the municipal group portrait, which had such a vogue in Holland in the later seventeenth century.

Collections: Ploos van Amstel, Verstock van Soelen, Leembruggen, Malcolm
1895-9-15-1130

113
CORNELIS VISSCHER
(1629?-1662)

A LITTLE BOY
Black chalk on vellum, with a touch of brown wash near the r. hand. 240:171
Signed.

1869-6-12-296

114
PIETER CORNELISZ VAN SLINGELANDT
(1640-1691)

A YOUNG WOMAN
Pencil, with touches of brown wash and white body-colour, on vellum. 120:102
Signed with monogram.

Collections: Leembruggen, Malcolm
1895-9-15-1311
Transparency PD 63

115
CORNELIS VISSCHER
(1629?-1662)

A MIDDLE-AGED MAN
Black chalk on vellum. 277:204
Signed and dated, *1652.*

Collections: Leembruggen, Malcolm
1895-9-15-1346

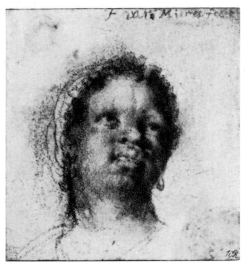

116 FRANS VAN MIERIS I
HEAD OF A NEGRESS

116
FRANS VAN MIERIS I
(1653-1681)

HEAD OF A NEGRESS
Black chalk. 67:62
Signed.

Collections: Robinson, Malcolm
1895-9-15-1212

117
JAN DE BISSCHOP
(c. 1628-1671)

DAVID VLUGH
Pen and brown wash over black chalk. 412:297

David Vlugh (d. 1673), Admiral of the Dutch fleet. The drawing was engraved by Hendrik Bary.

Collections: Verstolk van Soelen, Leembruggen, Malcolm
1895-9-15-1121

118
JAN GERRITSZ VAN BRONCHORST
(c. 1603-1661)

JACOB VAN DER DOES

Black chalk, with pen and brown ink on the coat-of-arms. 275:180
Signed and dated, *July 29 1655,* and inscribed with the sitter's name and age: *Aet. 33.*

Collection: Sheepshanks
1836-8-11-791

119
JAN DE BRAY
(c. 1627-1697)

MARIA VAN TEFFELEN
Black and red chalk. 232:179
Signed with monogram and dated, *1663,* and inscribed with the sitter's name and age: *aetatis 11.*

Collections: Leembruggen, Malcolm
1895-9-15-1129

120
CASPAR NETSCHER
(1639-1684)

TWO CHILDREN ON A BALCONY
Brush-drawing in Indian ink. 253:195

1885-7-11-269

121
MOSES VAN UYTENBROECK
(c. 1590-1648)

COUNT FERDINAND BOCSKAI
Red chalk, with a few touches of black chalk. 370:305
Signed and inscribed with the sitter's name.

Collection: Sheepshanks
1836-8-11-524

122
CASPAR NETSCHER
(1639-1684)

A YOUNG MAN WRITING A LETTER
Brush-drawing in Indian ink. 153:122

A study for the picture in Dresden, dated 1665.

Collections: Robinson, Malcolm
1895-9-15-1227

123
MOSES TER BORCH
(1645-1667)

(a) HEAD OF A YOUTH (SELF-PORTRAIT)
*Black chalk, heightened with white and with
touches of black pigment, on grey paper.* 103:100
Signed and dated, *1660.*

(b) HEAD OF A WOMAN
*Black chalk and grey wash, heightened with white
and with touches of black pigment, on grey paper.*
123:109 Transparency PD 64

The first letter of the inscription is hard to make
out, but it appears to be a 'G', and on the strength
of this the drawing was until recently attributed
to Gerard Ter Borch the Younger. But it is
certainly by the same hand as a group in the
Rijksmuseum traditionally given to his younger
brother Moses; several of these, of the same boy,
have been plausibly identified as self-portraits.

Oo. 10-138 and 139, bequeathed by Richard
Payne Knight in 1824

124
JAN DE BRAY
(1627-1697)

AN OLD MAN OF 80 (WRONGLY IDENTIFIED AS
SALOMON DE BRAY)
Black chalk. 200:173
Signed with initials and dated, *1648.* Inscribed
within the oval, *AET. SUE 81,* and in the car-
touche, *Salomon de Bray.* Another hand has added,
Obytt AD 1653. Salomon de Bray was born in
1597 and died in 1664, so that in 1648 (the date of
the drawing) he would have been only 51 years
old.

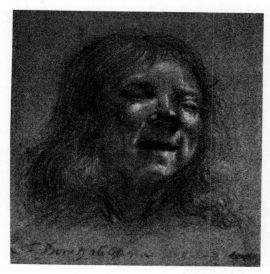

123a MOSES TER BORCH II
HEAD OF A YOUTH
(SELF-PORTRAIT?)

Collections: Robinson, Malcolm
1895-9-15-1127

125
Attributed to FRANS VAN MIERIS I
(1653-1681)

A LADY
Indian ink on vellum. The border in gold. 113:88
(oval)

1854-6-28-117

126
PAULUS MOREELSE
(1571-1683)

(a) PORTRAIT OF A MAN
Metalpoint. 74:58

(b) PORTRAIT OF A MAN
Metalpoint. 79:57

Collections: Verstolk van Soelen, Leembruggen,
Malcolm
1895-9-15-1220 and 1221

PORTRAITS OF ARTISTS

127
GIUSEPPE CESARI, il CAVALIERE D'ARPINO
(1568-1640)

SELF-PORTRAIT
Black and red chalk. 362:253

Inscribed on *verso* in a seventeenth-century hand: *Cau Giuseppe da se dipintosi,* and on the strip added to the lower edge: *Ritratto del Cavre Giuseppe Cesare d'Arpino: Originale di sua Mano.* The features suggest a man older than appears in Ottavio Leoni's etching of Cesari, dated 1621.

Collection: Malcolm
1895-9-15-664

128
RAPHAEL
(1483-1520)

SELF-PORTRAIT
Black chalk. 314:19

Inscribed in a late eighteenth- or early nineteenth-century hand: *Ritratto di se medessimo quando giovane.* The traditional identification of the drawing as a youthful self-portrait may well be correct. The style of the figure-studies on the other side of the sheet suggests a dating c. 1500, when Raphael would have been about sixteen or seventeen.

1890-9-16-94

129
RAFFAELLO MOTTA, called RAFFAELLINO DA REGGIO
(c. 1550-1578)

SELF-PORTRAIT
Black and red chalk. 362:253

Traditionally described as a portrait of Raffaellino da Reggio by his master Federico Zuccaro. The technique is Zuccaresque, but the handling suggests Raffaellino rather than Federico. The description of the drawing as a portrait of Raffaellino may rest on some old tradition, however, and certainly the intense expression and gaze are characteristics of self-portraits; but there is no authenticated likeness of this gifted but short-lived painter with which the drawing can be compared.

Collection: Malcolm
1895-9-15-659

130
HENDRICK GOLTZIUS
(1558-1617)

SELF-PORTRAIT
Black chalk on vellum, the shadows strengthened with lead pencil (graphite). 146:103
Signed with monogram.

Datable c. 1589

Collection: Malcolm
1895-9-15-1020

131
VENTURA SALIMBENI
(1568-1613)

SELF-PORTRAIT
Black chalk on greenish-grey paper. 365:253
Inscribed: *Ritratto di Ventura Salimbeni Orig. di sua m°.*

The elaborate ornamental border in grey wash dates from the eighteenth century and was probably executed in Italy. Many other self-portrait

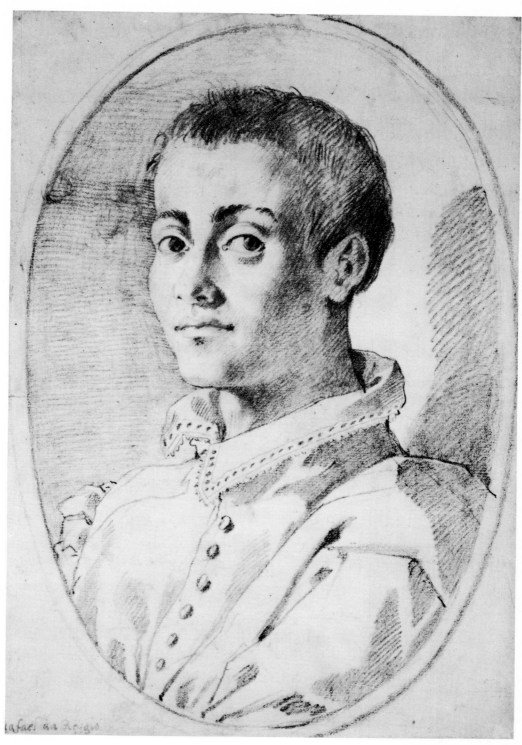

129 RAFFAELLO MOTTO
SELF PORTRAIT

drawings with such borders are known, all bearing the collector's mark of Charles Rogers, who must have acquired them *en bloc*, perhaps in an album.

Collections: Rogers, Malcolm
1895-9-15-585

132
BACCIO BANDINELLI
(1493-1560)

SELF-PORTRAIT
Black chalk, with brown wash in the background.
254:171

The style of the drawing is clearly that of Bandinelli, and the identification as a self-portrait is confirmed by comparison with the contemporary engraved portrait by Nicolas la Casa.

Collection: Malcolm
1895-9-15-555

133
Attributed to SALVATOR ROSA
(1615-1673)

GIOVANNI LORENZO BERNINI
Pen. 230:177
Inscribed, by the draughtsman: *Berninus Pictor, Sculptor, et Architectus.*

Pp. 5-103, bequeathed by Richard Payne Knight in 1824.

134
GIOVANNI LORENZO BERNINI
(1598-1680)

SELF-PORTRAIT AS A YOUNG MAN
Red chalk, with touches of white bodycolour on the nose and forehead. 365:264

Datable c. 1620.

1897-4-10-10
Transparency PD 10

135
GIOVANNI LORENZO BERNINI
(1598-1680)

SELF-PORTRAIT AS AN OLD MAN
Black chalk, with some yellowish bodycolour on the hair and forehead. 359:241

Datable c. 1675.

1890-10-13-5

136
CARLO DOLCI
(1616-1686)

SELF-PORTRAIT
Black and red chalk. 280:204

The intent gaze suggests that this may be a self-portrait. The features (so far as it is possible to compare them) conform satisfactorily with those in the profile self-portrait drawing in the Uffizi, dated 1674.

Collections: Spencer, Wellesley, Malcolm
1895-9-15-577
Transparency PD 9

137
OTTAVIO LEONI
(c. 1587-1630)

SELF-PORTRAIT
Black, red and white chalk on blue paper. 221:159

Numbered *299* and dated May 1624. Inscribed in another hand: *Cav Ottavio Leoni.*

Collection: Lempereur
1854-6-28-85

138
Attributed to SIMONE CANTARINI
(1612-1648)

PORTRAIT OF AN ARTIST (GIROLAMO ROSSI?)
Black and red chalk, with touches of white heightening, on (faded) blue paper. 265:245

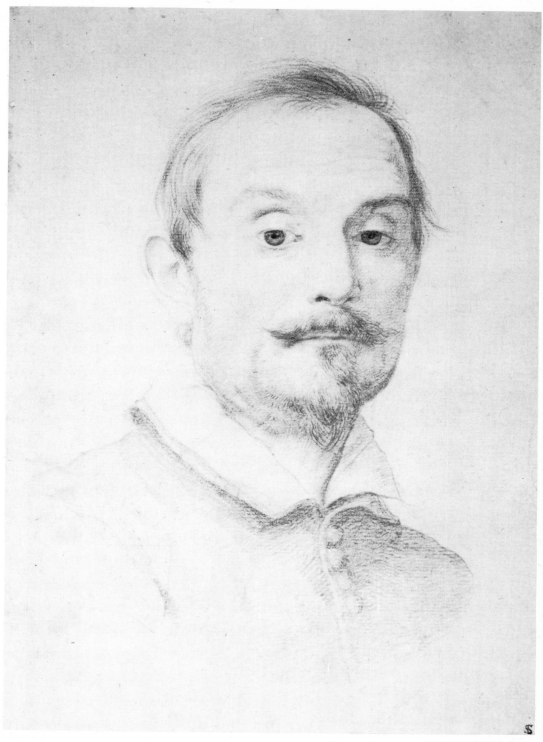

136 CARLO DOLCI
SELF PORTRAIT

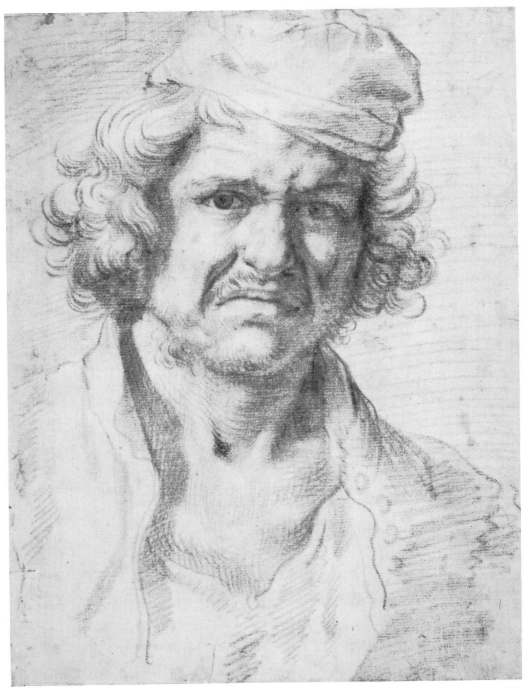

139 NICOLAS POUSSIN
SELF PORTRAIT

Girolamo Rossi the Elder (active 1632–64) is re-
corded in the biography of Cantarini as being one
of his favourite pupils 'whose portrait he several
times drew because of his good looks'. This
statement seems to be the only basis for the identi-
fication; and even the attribution of the drawing
to Cantarini is by no means certain.

Collection: Rogers
1850-12-14-202

139
NICOLAS POUSSIN
(1594–1665)

SELF-PORTRAIT
Red chalk. 259:198

The features agree in essentials with those of the
painted self-portrait, dated 1650, in the Louvre.
There seems to be no reason for doubting the
truth of the inscription, datable from the writing
in the late seventeenth century, which states that
the drawing is a self-portrait by Poussin made
c. 1630 when he was recovering from a severe
illness; and that he later gave it to Cardinal Camillo
Massimi who was taking drawing-lessons from
him (See A. F. Blunt, *Burlington Magazine,* lxxxix
(1947), p. 220).

1901-4-17-21
Transparency PD 11

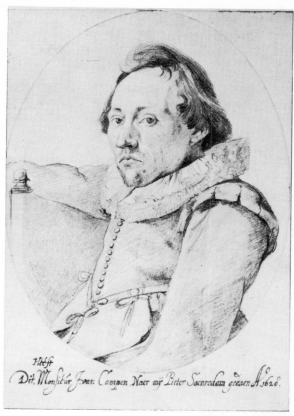

142 JACOB VAN CAMPEN
PIETER JANSZ SAENREDAM

140
CORNELIS VISSCHER
(1629?–1662)

SELF-PORTRAIT AT THE AGE OF TWENTY
Black chalk with touches of brown ink on vellum.
168:142
Inscribed *Aetatis XX* and dated *1649.*

Collection: Malcolm
1895-9-15-1343

141
JAN LIEVENS
(1607–1674)

JACOB MATHAM
Black chalk. 298:235.
Signed with initials and inscribed below: *Jacob
Matham Plaatsnyder.*

Jacob Matham (1571–1631), engraver.
1861-8-10-17

142
JACOB VAN CAMPEN
(1595-1657)

PIETER JANSZ SAENREDAM
Black chalk. Oval, laid down on another sheet. Size of whole sheet 260:182
Inscribed by the sitter: *Dit heeft Monsieur J. van Campen, Naer mij Pieter Saenredam gedaen A 1628.*

Pieter Saenredam (1597-1665), painter and draughtsman, whose speciality was the representation of church interiors.

1854-6-28-2
Transparency PD 13

143
REMBRANDT
(1606-1669)

SELF-PORTRAIT
Pen and brown ink and grey wash. 126:95

The strong contrast of light and shade shows that this was drawn by lamplight. Datable c. 1628-30.

Gg. 2-253, bequeathed by the Rev. C. M. Cracherode in 1799.
Transparency PD 12

144
JAN THOMAS
(1617-1673 or 8?)

GILLIS NEYTS
Lead pencil (graphite) on vellum, with touches of brown ink on the face. 137:93 (Octagonal)

Inscribed above: *gillis nyts* followed by a word possibly added by another hand, which has been read *pinxit*; below, *Jan Thomas fecit.*

Gillis Neyts (1623-1687), Flemish landscape painter, draughtsman and etcher.

Collection: Sheepshanks
1836-8-11-7252

145
MARCELLUS LAROON III
(1697-1772)

JOHN ROLLOS
Black chalk. 316:199
Inscribed by the draughtsman: *Mr Rolus his Majesty's Engraver of ye broad seal 1718.*

John Rollos, also spelt Roles, Rolus, Rollus (c. 1683-1743) was Engraver to the Royal Mint from 1726.
1876-7-8-2390

146
CARLO MARATTA
(1625-1713)

SELF-PORTRAIT

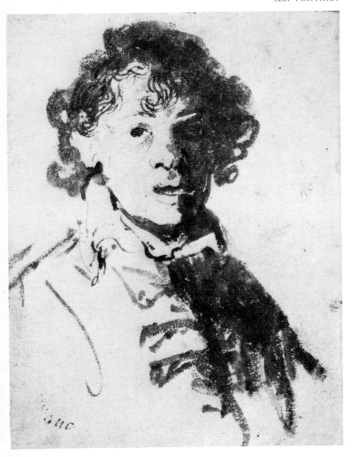

143 REMBRANDT
SELF PORTRAIT

Red chalk. 365:274

Inscribed: *Ritratto di Carlo Maratti di sua mano fatto il secondo di settembre 1684,* and on the old mount: *Given by Carlo Maratti to Sir Andrew Fountaine at Rome 1692.*

Sir Andrew Fountaine (1676-1753), of Narford Hall, Norfolk, was a friend of Leibniz, the German philosopher, and Swift. He was well-known as a connoisseur and collector.

1902-8-22-11

147
HENRY GYLES
(1645-1709)

SELF-PORTRAIT
Red and black chalk and watercolour, on buff paper. 313:227
Inscribed (by Ralph Thoresby, a friend of Gyles and fellow-member of a circle of antiquaries and *virtuosi* in York): *Ye effigies of Mr Hen: Gyles the celebrated Glass-painter at Yorke.*

1852-2-14-372

148
SIR PETER LELY
(1618-1680)

JOHN GREENHILL
Black, red and white chalk on grey paper. 273:200

John Greenhill (1640/5-1676) was one of Lely's pupils, and likewise a portrait-painter.

1857-11-14-213, presented by Sir Charles Robinson

149
SIR JOHN BAPTIST MEDINA
(1654-1710)

GRINLING GIBBONS
Red and black chalk, heightened with white, on buff paper. 227:172

Signed. Inscribed on the old mount (by George Vertue): *J Medina Eques ad vivum delin. G Gibbons Sculptor & . . .*

Grinling Gibbons (1648-1720), sculptor, specialising in wood-carving. He was Master Carver in Wood to the Crown from the time of Charles II to that of George I.

1852-2-14-375

150
JOHN GREENHILL
(1640/5-1676)

SELF-PORTRAIT
Black and red chalk, heightened with white, on buff paper. 239:190
Signed with monogram.

1886-11-23-1

151
JOHN WOOTTON
(c. 1686-1765)

SELF-PORTRAIT
Black and red chalk on buff paper. 204:164
Inscribed: *Mr Wootton's own portrait by himself.*

Wootton was one of the first English painters to specialise in sporting (especially hunting and racing) subjects.

1956-10-13-3

152
JONATHAN RICHARDSON The Elder
(1665/7-1745)

SELF-PORTRAIT
Black chalk, touched with white chalk, on blue paper. 440:295
Dated 24 June 1728 and inscribed, by Horace Walpole: *His son has written on the back Ubi se a vulgo & scena, in secreta remorat.*

1902-8-22-44
Transparency PD 14

153
RANIERI DEL PACE
(1684–after 1733)

SELF-PORTRAIT
Black chalk. 371:244
Inscribed by the draughtsman: *Ritratto di Ranieri del Pace Pittor fiorentino fatto da se medesimo anno 1733 nella sua eta d' Anni 49.*

A native of Pisa and pupil of Domenico Gabbiani in Florence, he worked mainly in Florence and Pisa.

1874-1-10-429

154
CHARLES GRIGNION The Younger
(1754–1804)

RICHARD YEO
Black chalk, heightened with white bodycolour, on brownish-grey paper. 132:113
Inscribed: *Mr Yeo, Die Engraver to the Mint.*

Richard Yeo (d. 1779), medallist and die-cutter. He was Assistant Engraver to the Royal Mint in 1749 and Chief Engraver in 1775.

1962-7-14-35, bequeathed by Iolo Williams

155
ANTOINE WATTEAU
(1684–1721)

AN ENGRAVER AT HIS WORK-TABLE
Red chalk. 236:304

1874-8-8-2279

156
J. WELLER
(b. 1699)

SELF-PORTRAIT AT THE AGE OF TWENTY
Black chalk, heightened with white. 293:253
Inscribed by the draughtsman: *J Weller se ipse ad vivum delineavit Augusti die 30, 1718. Aetat. 20.*

Nothing is known of Weller beyond the evidence provided by this and another portrait drawing also in the collection (not exhibited). An inscription on the latter suggests that he may have been active in Reading.

1852-2-14-373

157
JOHN CARTER
(1748–1817)

BENJAMIN CARTER
Watercolour. 427:264
Inscribed on the open book, lower l.: *Mem: This figure represents Bⁿ Carter, statuary, copied from a painting (same size) of Rᵈ Pyle 1760, where-in are numbered other portraits of tradesmen in the building branch.*

Benjamin Carter (d. 1766), was a sculptor specialising largely in monuments and chimney-pieces. He was the father of the artist of the drawing, who was well known as an antiquarian and writer on architectural subjects. The painting by Richard Pyle referred to in the inscription was formerly in the collection of J. Bowyer Nichols, and was sold at Christie's on 19 July 1929, lot 32. The principal figure in it is Henry Keene, Architect to the Dean and Chapter of Westminster. Benjamin Carter, standing exactly as in the drawing, appears in the left foreground. Only the figure is copied: the interior in which it is standing is the work of the draughtsman.

1908-7-14-48

158
WILLIAM HOARE, known as 'Hoare of Bath'
(1706–1799)

CHRISTIAN FRIEDRICH ZINCKE
Black and red chalk. 415:318
Inscribed below by the draughtsman: *Frederick Zink, painter in Enamel drawn by William Hoare from his Love and Friendship as well as many Obligations to him, in the year 1752, Mr Zink being at that*

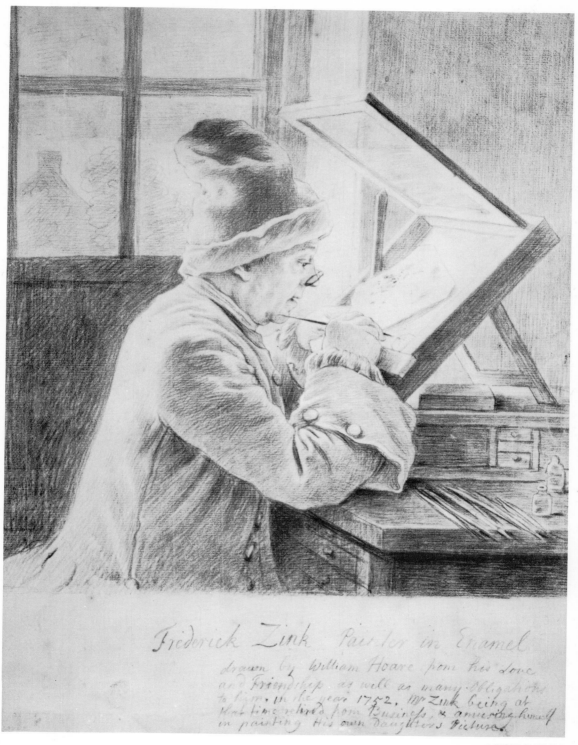

Frederick Zink Painter in Enamel
drawn by William Hoare from his Love
and Friendship as well as many Obligations
to him in the year 1752. Mr Zink being at
that time retired from Business, & amusing himself
in painting His own daughters Pictures.

158 WILLIAM HOARE
CHRISTIAN FRIEDRICH ZINCKE

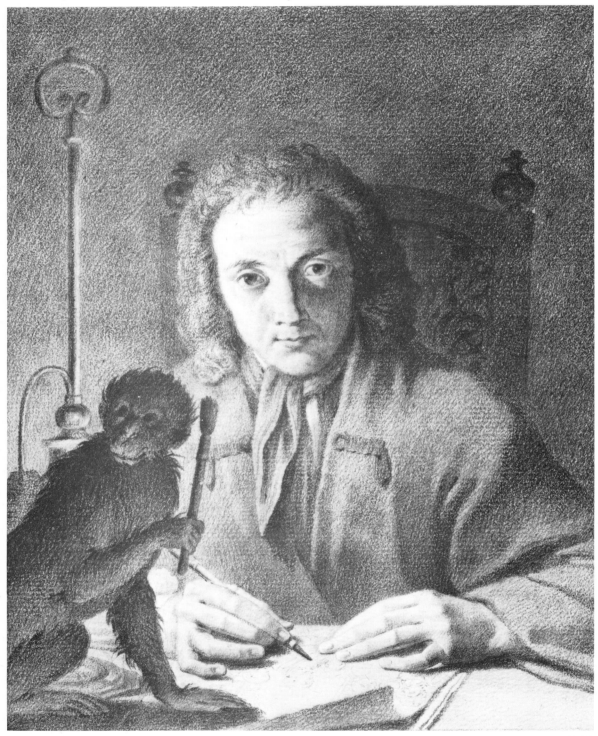

159 GIOVANNI DOMENICO CAMPIGLIA
SELF PORTRAIT

time retired from Business, & amusing himself in painting his own Daughter's picture.

Christian Friedrich Zincke (1684?-1767), born in Dresden, came to England in 1706. He specialised in painting portrait-miniatures in enamel. These had a great vogue, but in 1746 he retired from his profession and settled in Lambeth, where the present drawing was presumably made.

1860-7-28-167
Transparency PD 15

159
GIOVANNI DOMENICO CAMPIGLIA
(1692-1768)

SELF-PORTRAIT
Black chalk. 418:260
Inscribed below: *Portrait of Campidglia* [sic] *drawn by himself and given to me by him C.F. 1738.* 'C.F.' is explained as standing for Sir Charles Frederick.

Campiglia worked mainly in Florence and Rome, chiefly as an engraver and draughtsman. A blank space intended for an inscription below the drawing (covered by the mount) shows that it was made to be engraved.

1865-1-14-820
Transparency PD 16

160
GIOVANNA FRATELLINI
(1660-1731)

IGNATIUS HUGFORD
Red chalk. 280:197
A long inscription, dated 4 April 1779, by the Florentine collector and antiquary Lamberto Gori, records the authorship of the drawing and his purchase of it at the sale of Hugford's effects after his death.

Ignatius Hugford (1703-1778), born in Pisa of English extraction. Active in and around Florence as a painter, but better known as an expert and dealer in works of art.

1972-5-13-13, presented by Christopher Norris

161
NATHANIEL DANCE
(1734-1811)

JAMES BARRY IN ROME
Pencil. 260:196
Inscribed by the draughtsman:
> On his coming to Rome Barry swore with a frown
> Every Man who oppos'd him he'd kick or knock down.
> Having found his mistake with the few that he try'd
> Now rather than quarrel he'll kiss your Backside

Barry is saying: 'No soup magre. The Blue Bells of Ireland', and the other figure 'Monsieur Roast Beef'.

James Barry (1741-1806), historical painter, born in Cork. He was in Rome from 1770 to 1776, where 'the contentiousness of his disposition . . . engaged him in perpetual strife with nearly everyone he met, including his brother artists'. His chief works were two large paintings illustrating the History of Human Culture, executed between 1777 and 1783 for the Society of Arts, and still in their premises in the Adelphi.

1868-6-12-2136

162
NATHANIEL HONE
(1718-1784)

(a) SELF-PORTRAIT
 Pen and brown wash. 150:110
 Signed with monogram and dated, *1764.*

(b) SELF-PORTRAIT
 Black chalk touched with white chalk on pinkish-brown paper. 182:130
Signed.

1890-10-13-17 and 16

166 JAMES DEACON
MRS SCOTT, SAMUEL SCOTT

163
WILLIAM WOOLLETT
(1735–1785)

SELF-PORTRAIT
Red chalk. 377:319

According to tradition, a self-portrait of Woollett at the age of 22 (i.e. c. 1757); but there is some reason to suppose that this may be a drawing, not necessarily by Woollett himself, of someone closely resembling him in feature (see L. Binyon, *Catalogue of Drawings by British Artists . . . in the British Museum,* iv, p. 363).

1863-11-14-806
Transparency PD 18

164
GERVASE SPENCER
(d. 1763)

SELF-PORTRAIT
Grey wash. 127:108

A small etched portrait, corresponding with this drawing in reverse, is inscribed with the name of Reynolds. Spencer is known to have possessed a portrait of himself by Joshua Reynolds (now lost). If the etching was made from that portrait, then the present drawing would presumably also have been copied from it; but the drawing has all the appearance of a self-portrait made directly from life.

1881-6-11-187

165
JOHN ZOFFANY
(1733–1810)

SELF–PORTRAIT
Black chalk. 305:280 (Oval)

Datable c. 1790

1927-4-19-1

166
JAMES DEACON
(c. 1728–1750)

(a) MRS SCOTT
(b) SAMUEL SCOTT
Pencil and grey wash. 83:62 and 91:77
Inscribed on the old mount in ink: *Mrs Scott by Mr Deacon* and *Samuel Scott by Mr Deacon.*

Samuel Scott (c. 1710–1772), painter of marine subjects and Thames-side views in and near London. Sometimes known as 'the English Canaletto'.

1852-2-14-379-380
Transparency PD 17

167
SIR JOSHUA REYNOLDS
(1723–1792)

SELF PORTRAIT
Black chalk touched with white chalk on blue paper. 412:273
Inscribed: *Rome 1760.*

1897-6-15-1

168
SIR THOMAS LAWRENCE
(1769–1830)

HENRY FUSELI
Pencil. 272:195

Henry Fuseli (1741–1825), born Heinrich Fuessli in Zurich. Came to England 1763. Elected R.A. 1790 and Professor of Painting at the Royal Academy 1799. His paintings and drawings are expressions of Romanticism at its most extreme.

1890-4-15-175

169
JOHN RAPHAEL SMITH
(1752–1812)

THOMAS ROWLANDSON
Black chalk over pencil, with some grey wash. 280:207

Thomas Rowlandson (1756–1827), draughtsman in watercolour and caricaturist.

1890-10-13-18

170
THOMAS UWINS
(1782–1857)

CHARLES GRIGNION
Pencil. 208:144
Inscribed on the mount. *Taken at 92 years of age. He was born October 25th 1717. Died November 1810, aged 93.*

Grignion, who was born in London, studied under Gravelot. He was an engraver, who worked after Hogarth, Hayman, Mortimer, and – towards the end of his long life – Stothard. A long inscription on the back of the drawing gives an account of his career. He is described as 'small of stature, and an interesting countenance, and so much like Garrick that they have been frequently mistaken for one another'.

1855-5-12-315

171
JOHN RAPHAEL SMITH
(1752–1812)

SELF PORTRAIT
Black chalk, with touches of red chalk and grey wash on the face. 253:187

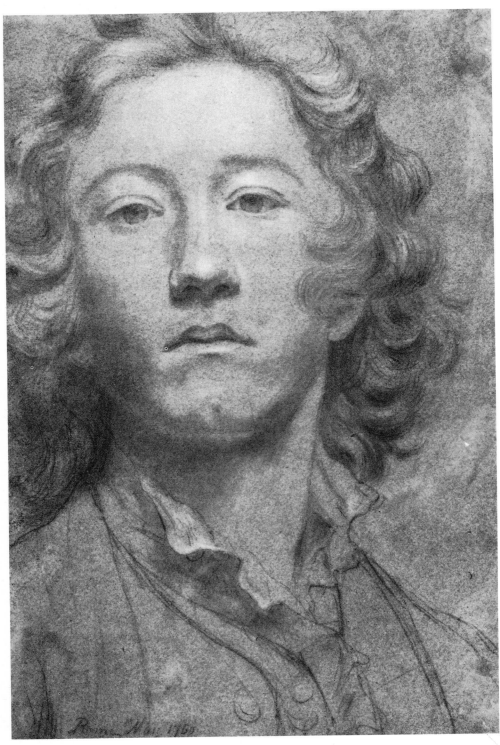

167 SIR JOSHUA REYNOLDS
SELF PORTRAIT

Painter and engraver. One of the greatest masters of mezzotint, especially famous for his prints after Reynolds.

1868-3-28-327

172
HENRY EDRIDGE
(1769-1821)

EDWARD FRANCIS BURNEY
Pencil and grey wash. 170:138

Edward Francis Burney (1760-1848), painter and draughtsman. Mainly active as a book-illustrator.

1867-4-13-528

173
HENRY EDRIDGE
(1769-1821)

THOMAS STOTHARD
Pencil and grey wash. 170:131

Thomas Stothard (1755-1834), painter and draughtsman, particularly well-known for his designs for book illustration.

1867-4-13-531

174
PIERRE-ETIENNE FALCONET
(1741-1791)

PAUL SANDBY

Black chalk, with pink wash on the collar. 177:125
Signed with initials and dated, *1768.*

Paul Sandby (1725-1809), landscape painter in watercolour and engraver. He introduced the aquatint process into England in 1775.

1868-8-8-1967

175
EDWARD EDWARDS
(1738-1806)

SELF-PORTRAIT

Black and red chalk and grey wash. 182:146

Edward Edwards, painter and etcher, but better remembered for his *Anecdotes of Painters* (1808) which continues Horace Walpole's *Anecdotes of Painting in England* (1762).

1867-4-13-537

176
JOHN HAMILTON MORTIMER
(1741-1779)

SELF-PORTRAIT
Pen and black ink. 456:379 (oval)

1859-7-9-70

177
RICHARD COSWAY
(1742-1821)

THOMAS BANKS
Pencil. 145:115
Inscribed *Thomas Banks Esq.* Stamped with Banks's own collector's mark (Lugt 2423).

Evidently a study for a miniature. Thomas Banks (1735-1805), neo-classic sculptor and collector of drawings by the Old Masters.

1965-12-11-34, presented by C. F. Bell

178
JEAN-BAPTISTE-JOSEPH WICAR

GIUSEPPE LONGHI
Black chalk. 338:246. *Size of oval subject,* 297:235
Signed with initial and dated, *1802.* Inscribed below: *The Chevalier Longhi Professor of the Fine Arts in Milan drawn by Wicar.*

Giuseppe Longhi (1766-1831), engraver and draughtsman. Wicar is best known as a collector. He formed a magnificent collection of drawings by the Old Masters, especially Raphael, part of which is now in the Musée Wicar at Lille, his native city.

1859-7-9-1925

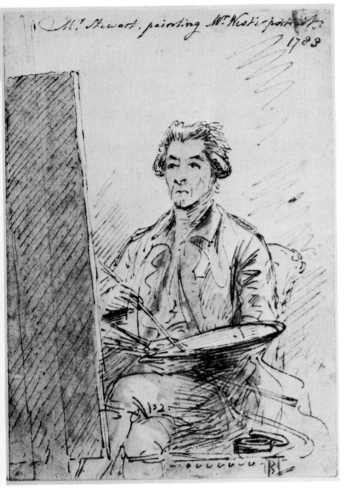

180 BENJAMIN WEST
MR STEWART PAINTING MR WEST'S PORTRAIT

179
THOMAS ROWLANDSON
(1756-1827)

GEORGE MORLAND
Pen and black ink and watercolour. 315:215

George Morland (1763-1804), painter of senti-
mental and rustic *genre*.

1868-3-28-335

180
BENJAMIN WEST
(1738-1820)

MR STEWART PAINTING MR WEST'S PORTRAIT
Pen and brown wash. 178:122
Inscribed as above, and dated (in another hand)
1783.

Gilbert Stuart (1755-1828), American portrait
painter and pupil of West, in whose studio he
worked from 1775 to 1780. In 1781 he exhibited
a portrait of West at the Royal Academy, which
may be the one now in the National Portrait
Gallery.

1946-11-13-149, presented by Eric Rose

181
SIR GEORGE HAYTER
(1792-1871)

HENRY FUSELI
Pen and black ink on grey paper. 167:147
Signed with initials and dated, *Jan 7 1812.*

1889-6-3-258

182
FREDERICK TATHAM
(1805-1878)

MRS WILSON
Watercolour over black chalk. 523:313
Signed, and inscribed by the draughtsman: *This
drawing was made from a Mrs Wilson who lived in a
hut upon Epping Forest. I drew her because she was so*

like William Blake – indeed this portrait of Mrs Wilson is much more like Blake than any hitherto published except that Mr Phillips engraved in Blair's Grave.

1867-10-12-240

183
GEORGE RICHMOND
(1809-1896)

WELBY SHERMAN
Pencil. 231:199
Dated, *1827*, and inscribed: *Portrait of W Sherman drawn by George Richmond R.A. Sherman engraved, in mezzotint, one of Palmer's early pictures – a Miltonic subject.*

Little is known of Sherman except that he was a member of Samuel Palmer's circle in the 1820's and was with him at Shoreham. The engraving after Palmer referred to is the very rare mezzotint entitled *Evening.*

1929-4-16-4

184
JOHN FLAXMAN
(1755-1826)

THOMAS STOTHARD
Black chalk. 172:147

See no. 173

1878-7-13-1257

185
HENRY WALTER
(1789-1849)

SAMUEL PALMER
Pencil with brown and grey wash. 296:226
Signed and dated, *July 20 1819.*

Samuel Palmer (1805-1881), visionary landscape painter and etcher. Walter was one of the group of Palmer's friends at Shoreham in the 1820's.

1936-4-9-56

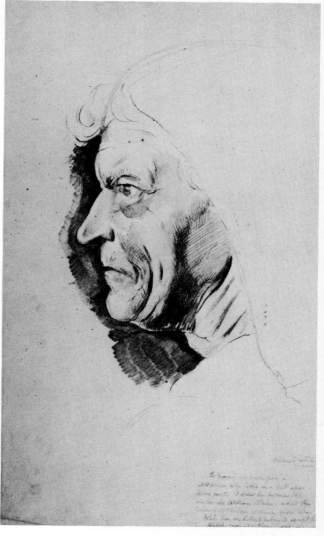

182 FREDERICK TATHAM
MRS WILSON

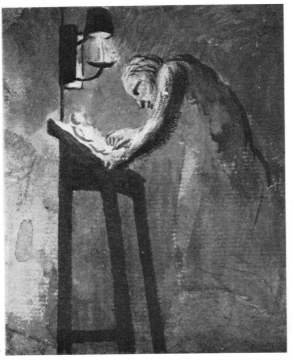

186 WILLIAM YOUNG OTTLEY
JOHN FLAXMAN

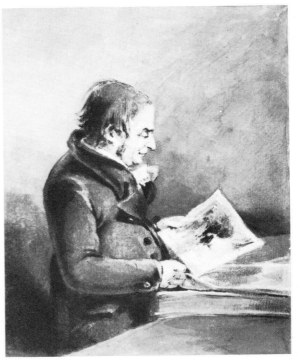

187 JOHN THOMAS SMITH
J. M. W. TURNER

186
WILLIAM YOUNG OTTLEY
(1771-1836)

JOHN FLAXMAN
Pen and brown ink and grey wash. 94:74

John Flaxman (1755-1826), neo-classic sculptor
and draughtsman. Ottley, who was Keeper of
Prints and Drawings in the British Museum from
1833 to 1836, was an amateur draughtsman also
in the neo-classic style.

1885-5-9-1575
Transparency PD 19

187
JOHN THOMAS SMITH
(1766-1833)

J. M. W. TURNER
*Grey and brown wash, heightened with white, over
pencil. 222:182*

Smith was Keeper of Prints and Drawings from
1816 to 1833. The drawing shows Turner in the
Print Room.

1885-5-9-1648
Transparency PD 20

188
EDWARD BIRD
(1772-1819)

J. M. W. TURNER
Pencil. 114:82

1894-5-16-4

189
CHARLES TURNER
(1774-1857)

(a) J. M. W. TURNER
Pencil. 183:116
Inscribed: *A Sweet Temper*

(b) J. M. W. TURNER
Pencil. 184:140

Charles Turner was an engraver, who made many of the plates for his namesake's *Liber Studiorum* and *Rivers of England.*

1842-4-11-10 and 9

190
WILLIAM MULREADY
(1786-1863)

JOHN VARLEY
Black chalk on grey paper. 165-137

John Varley (1778-1842), one of the most prolific and influential artists of the English watercolour school.

1878-7-13-1271

191
HORACE BEEVOR LOVE
(1800-1838)

JOHN SELL COTMAN
Pencil and watercolour. 272:243
Signed and dated, *1830.*

John Sell Cotman (1782-1842), landscape painter, particularly in watercolour, and etcher, of the

Norwich School. The inscription 'Normandie' on the book he holds is a reference to his publication *The Architectural Antiquities of Normandy,* 1822.

1902-5-14-442

192
HENRY EDRIDGE
(1769-1821)

JOSEPH FARINGTON
Pencil, with grey wash and touches of red chalk on the face. 185:150

Joseph Farington (1747-1821), landscape painter and topographical draughtsman. Chiefly remembered today for his *Diary.*

1891-5-11-39

193
GEORGE HENRY HARLOW
(1787-1819)

JAMES NORTHCOTE
Pencil, with touches of red chalk on the hands and face. 234:191

James Northcote (1746-1831), painter of portraits and historical subjects. A pupil, and biographer, of Joshua Reynolds, he also wrote a life of Titian. William Hazlitt's *Conversations with James Northcote* were published in 1830.

1891-5-11-45

194
HENRY MONRO
(1791-1814)

DR THOMAS MONRO
Pencil. 173:120
Signed and dated, *Oct. 1813.*

Thomas Monro (1759-1833), physician, connoisseur, patron of the arts and amateur draughtsman. His informal 'academy' for young artists

was attended by J. M. W. Turner, Girtin, John Varley, Peter de Wint and others of the English watercolour school. Henry Monro was his son.

1961-5-13-2, presented by P. D. O. Coryton

195
SIR RICHARD OWEN
(1804-1892)

ROBERT HILLS
Pencil. 347:258
Inscribed: *Rob^t Hills Esq^re An excellent likeness. Sketched one evening by Richard Owen in April, 1835. First Sec^y: to the Society of Painters in Water-colours.*

Robert Hills (1769-1849), watercolour painter and etcher, specialising in farm-yard scenes and animals.

1893-8-3-1, presented by the Executors of Sir Richard Owen KCB

196
GEORGE DANCE
(1741-1825)

THOMAS GIRTIN
Pencil with touches of red chalk on the ear and lips. 253:193
Signed and dated, *Aug^st 28th 1790.*

Thomas Girtin (1775-1802), one of the greatest English watercolour painters.

1898-7-12-21
Transparency PD 21

197
CHARLES ROBERT LESLIE
(1794-1859)

JOHN MARTIN
Pencil with touches of red chalk on the face and pen and ink on the eyes, nostrils and lips. 195:138
Signed and dated, *1822.*

John Martin (1789-1854), painter and mezzotint engraver, well-known for his grandiose landscapes and historical compositions.

1859-7-9-65

198
PENRY WILLIAMS
(1798-1885)

SIR AUGUSTUS CALLCOTT
Pencil. 114:86
Signed with initials.

Augustus Wall Callcott (1779-1844), landscape painter and etcher.

1925-12-14-2, presented by Dr Augusto Calabi

199
CHARLES MARTIN
(1820-1906)

WILLIAM MULREADY
Pencil. 169:114

William Mulready (1786-1863), painter and book-illustrator. This drawing was reproduced in *The Fine Arts Quarterly Review* as the work of Mulready himself, drawn in 1836. A letter from Martin was subsequently published, claiming the authorship and stating that the drawing was made in 1844.

1876-12-9-382

200
ANONYMOUS, 1878

WILLIAM POWELL FRITH
Pen and brown ink over pencil. 147:109
Inscribed: *"I am told that this ('Nocturne in Blue & Silver') represents moonlight. It does so in the same way that a piece of wall paper coloured like it would."* Called for Def[endan]t Ruskin (Back).

William Powell Frith (1819-1909), painter of *genre* and subject pictures. The inscription refers

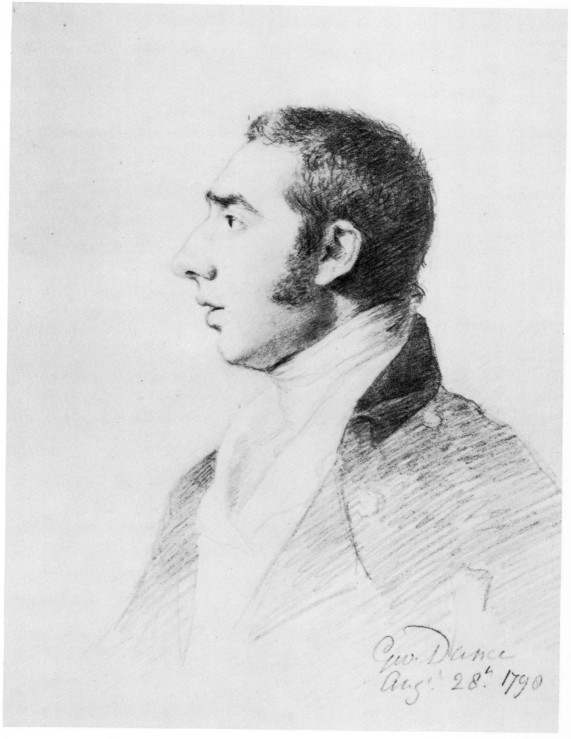

196 GEORGE DANCE
THOMAS GIRTIN

to his evidence on behalf of the defendant, in the libel action (November 1878), in which Whistler sued Ruskin for saying that his *Nocturne in Blue and Silver* was 'a pot of paint thrown in the public's face'.

1973-5-1-2, presented by Edward Croft-Murray

201
GEORGE CRUICKSHANK
(1792-1878)

(a) SELF-PORTRAIT
Pencil. 138:100

(b) THREE SELF-PORTRAIT SKETCHES
Pencil. 183:110
Signed and inscribed: *Self . . . at work.*

Satirical draughtsman and etcher, and Temperance reformer.

1972-U 550 and 551

202
CHARLES ROBERT LESLIE
(1794-1859)

CLARKSON STANFIELD, J. J. CHALON, AND A. E. CHALON IN FANCY DRESSES. PAINTED ON TWELFTH NIGHT
Brown, grey and black wash over pencil. 339:434
Signed, and inscribed as above.

1954-1-13-1

203
JOHN PARTRIDGE
(1790-1872)

A MEETING OF THE SKETCHING SOCIETY
Pen and black ink and brown and black wash, heightened with white. 214:295

On a reproduction of this drawing published in 1858, the figures are identified as: A. E. Chalon, R. T. Bone, J. Partridge, J. C. Robertson, G. F. Robson, J. Cristall, C. R. Leslie, S. J. Stump, Clarkson Stanfield, J. J. Chalon and T. Uwins.

1887-11-16-2

204
JOHN HAYTER
(1800-1895)

SIR CHARLES EASTLAKE
Pencil and grey wash, heightened with white, on buff paper. 281:216

See no. 209.

1890-10-13-7

205
SOLOMON ALEXANDER HART
(1806-1881)

(a) CHARLES LANDSEER
Pen and brown ink. 110:94
Inscribed: *Athenaeum, Chas. Landseer, October 184 . . .*

Charles Landseer (1799-1879), painter of historical subjects. Elder brother of Sir Edwin Landseer.

(b) HARVEY ORRIN SMITH
Pencil. 178:222
Inscribed: *H. Orrin Smith 85 Hatton Garden.*

Harvey Orrin Smith, or Orrinsmith, wood engraver.

(c) OLD TOWNSEND THE BOW STREET RUNNER
Pen and brown wash over pencil. 142:87

1881-11-12-373, 374 and 371

206
EDUARD JACOB VON STEINLE
(1810-1886)

FREDERIC LEIGHTON
Pencil. 365:305

Frederic Leighton (1830-1896), painter of idealised classical subjects and President of the Royal Academy. The present drawing probably dates

from c. 1850, when Leighton was studying under Steinle in Frankfurt.

1887-12-16-10

207
JOHN HAYTER
(1800-1895)

SIR GEORGE HAYTER
Black ink and brown wash over pencil, with touches of white bodycolour. 180:192

Sir George Hayter (1792-1871), portrait painter. Painter to the Queen, 1841, knighted 1842. John Hayter was his younger brother.

1867-3-9-1851

208
HENRY TANWORTH WELLS
(1828-1903)

ALFRED WILLIAM HUNT ON HIS DEATHBED
Pencil. 261:361
Signed with monogram and dated, *May 4th 1896.*

Alfred William Hunt (1830-1896), landscape painter.

1936-12-21-2

209
SIR GEORGE HAYTER
(1792-1871)

(a) SIR CHARLES EASTLAKE
Grey wash over pencil. 96:74

Sir Charles Eastlake (1793-1865), painter and connoisseur. President of the Royal Academy and Director of the National Gallery.

(b) SEYMOUR KIRKUP AND SIR CHARLES EASTLAKE
Pencil and brown wash, heightened with white. 92:204

Seymour Kirkup (1788-1880), painter. Lived mainly in Florence, and is chiefly remembered

for his discovery in 1840 of Giotto's fresco portrait of Dante.

(c) MORITZ RETZSCH
Pencil. 173:106
Signed and dated; *Oct 8 1843* and inscribed: *Moritz Retsch, from nature, at his villa.*

Moritz Retzsch (1779-1857), German draughtsman and book-illustrator.

(d) ANTONIO CANOVA
Pen and brown wash over pencil. 181:114
Inscribed: *The general arrangement is like this but the likeness in character must not be looked for here, as it is only to show the view of his head which I have taken.*

1890-10-13-14, 13, 9 and 12

210
SIR WILLIAM ROTHENSTEIN
(1872-1945)

H. B. BRABAZON
Black, white and two shades of red chalk on grey paper. 176:198
Signed with initials.

Hercules Brabazon Brabazon (1821-1906), amateur landscape draughtsman, influenced particularly by Turner's late style. He was not 'discovered' until the 1890's.

1904-1-16-1, presented by the artist
Transparency PD 22

211
SIR WILLIAM ROTHENSTEIN
(1872-1945)

AUGUSTUS JOHN
Black, brown, red, yellow and white chalk on grey paper. 387:284

Augustus John (1878-1961), painter and draughtsman, especially of portraits. Probably drawn c. 1900.

1930-1-11-1, presented by the Contemporary Art Society

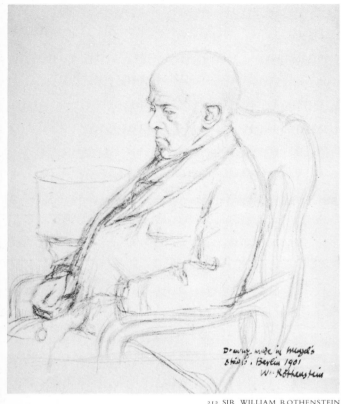

212 SIR WILLIAM ROTHENSTEIN
ADOLF MENZEL

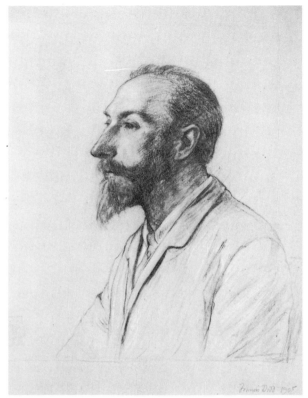

213 FRANCIS DODD
CHARLES RICKETTS

212
SIR WILLIAM ROTHENSTEIN
(1872-1945)

ADOLF MENZEL
Pencil. 354:246
Signed and inscribed: *Drawing made in Menzel's Studio, Berlin 1901.*

Adolf Menzel (1815-1905), German painter and draughtsman.

1945-12-8-50, presented by the Contemporary Art Society
Transparency PD 23

213
FRANCIS DODD
(1874-1949)

CHARLES RICKETTS
Black, red and white chalk on grey paper. The (turquoise) tie-pin in green chalk. 380:280
Signed and dated, *1905.*

Charles de Sousy Ricketts (1866-1931), painter, book-illustrator, stage-designer, writer, collector and connoisseur.

1940-2-10-7

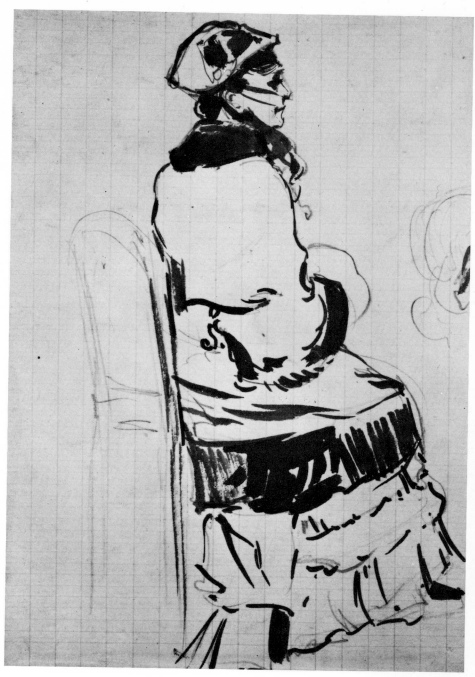

214 EDOUARD MANET
BERTHE MORISOT

214
EDOUARD MANET
(1832-1883)

BERTHE MORISOT
Pencil and indian ink and brush on squared paper.
180:125

Berthe Morisot (1841-1895), painter, sister-in-law of Manet.

1935-12-14-7, purchased with the aid of a donation from Mr Louis Clarke

215
AUBREY BEARDSLEY
(1872-1898)

SELF-PORTRAIT
Pen and indian ink. 253:94

1906-4-23-1, presented by Robert Ross

216
JEAN-EDOUARD LACRETELLE
(1817-1900)

FREDERICK GOULDING
Pencil. 227:150
Signed, and inscribed: *Portrait of FG about 1880.*

Frederick Goulding (1842-1909), master printer of etchings; worked for most of the English etchers of the later nineteenth century, especially Whistler.

1939-1-5-1

217
SIR CHARLES HOLROYD
(1861-1917)

WALTER RICHARD SICKERT
Metalpoint and white bodycolour on yellowish-buff prepared paper. The outline of the lips and chin emphasised (and corrected) in pencil. 238:188
Signed and dated, *1897.*

Walter Richard Sickert (1860-1942), painter.

1939-3-11-7, presented by Michael Holroyd

218
ERNEST BOROUGH JOHNSON
(b. 1866)

SIR HUBERT VON HERKOMER
Black chalk, with some brown wash and pencil.
524:404

Signed and inscribed: *À mon Professeur Hubert von Herkomer R.A. 1892. Drawing for Oil portrait in Nottingham Art Gallery 1943.*

Hubert von Herkomer (1849-1914), painter.

1948-7-29-3, presented by A. L. Cox

219
MERLYN EVANS
(1910-1973)

SIR WILLIAM COLDSTREAM
Pencil. 583:396
Dated, *21st Jan 56 – 4th Feb 56.*

William Coldstream (b. 1908), painter, Professor at the Slade School.

1971-3-15-18

220
VIVIAN FORBES
(1891-1937)

HENRI MATISSE
Pencil, with some blue wash in the background.
269:205
Signed and dated, *1930.*

Henri Matisse (1869-1954), painter, one of the leaders of the 'fauve' movement.

1936-6-13-9*, presented by the Contemporary Art Society

221
FRANCIS DODD
(1874–1949)

DAVID MUIRHEAD
Black chalk. 375:277
Signed and dated, *1915*.

David Muirhead (1867–1930), painter.

1949-4-11-31, bequeathed by Campbell Dodgson

222
ARTHUR ELLIS
(b. 1856)

C. W. SHERBORN IN HIS STUDIO
Grey wash. 248:402

Signed and dated, *1898*.

Charles William Sherborn (1831–1912), engraver.

1944-7-8-3, bequeathed by C. D. Sherborn.

223
PAUL DRURY
(b. 1903)

ALFRED DRURY
Conté crayon. 368:272
Signed and dated, *5th Aug. 1937* and inscribed (presumably a record of the length of time it took to make the drawing): *20 mins.*

Alfred Drury (1856–1944), sculptor.

1945-12-8-17, presented by the Contemporary Art Society

222 ARTHUR ELLIS
C. W. SHERBORN IN HIS STUDIO

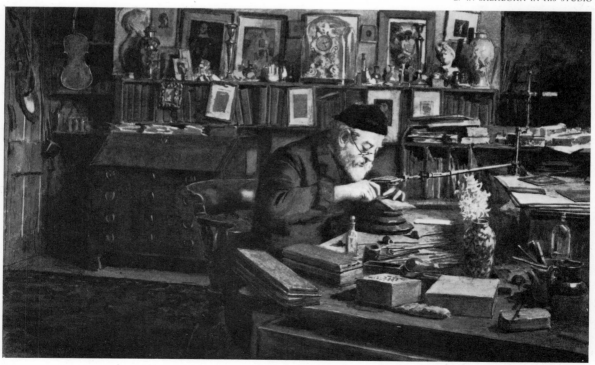

CARICATURE

224
SIENESE SCHOOL
(c. 1530)

SHEET OF CARICATURE SKETCHES
Pen and brown ink. 291:218

One of many sketchbook leaves by an as yet unidentified draughtsman, referred to for convenience as 'the Pseudo Pacchia', who was evidently Sienese and influenced by Girolamo della Pacchia and Sodoma.

1954-11-26-2

225
FERRAÙ FENZONI
(1562-1645)

NICODEMO FERRUCCI
Pen and brown ink. 270:178
Inscribed in a seventeenth-century hand: *ferrauto fanzoni* (the name repeated in Greek characters), and on the back, also in Greek characters, *nicodemo feruzzi*.

The inscription presumably refers to the Florentine painter Nicodemo Ferrucci (1574-1650).

1947-10-11-21

226
LEONARDO da VINCI
(1452-1519)

(a) CARICATURE OF AN OLD WOMAN
 Pen and brown ink. 57:42

(b) CARICATURE OF AN OLD MAN
 Pen and brown ink. 57:40

Pp. 1-37 and 38, bequeathed by Richard Payne Knight in 1824

227
CARLO MARATTA
(1625-1713)

CARICATURE OF AN OLD MAN IN PROFILE
Red chalk. 185:153

Collections: Houlditch, Reynolds.
Ff. 3-206, bequeathed by the Rev. C. M. Cracherode in 1799

228
CARLO MARATTA
(1625-1713)

CARICATURE OF SEVEN CARDINALS
Red chalk. 190:356
Inscribed on the back of the mount, in an early eighteenth-century hand (Jonathan Richardson's): *Carlo [Maratta] had a Mistress which some of the Jesuit Cardinals persuaded the Pope to cause to be driven from him; in Revenge he Caricatura'd 'em all. This is it.*

1956-5-12-3

229
PIERFRANCESCO MOLA
(1612-1666)

CARICATURE OF A MAN
Pen and brown wash. 207:173

1958-10-11-5

225 FERRAÙ FENZONI
NICODEMO FERRUCCI

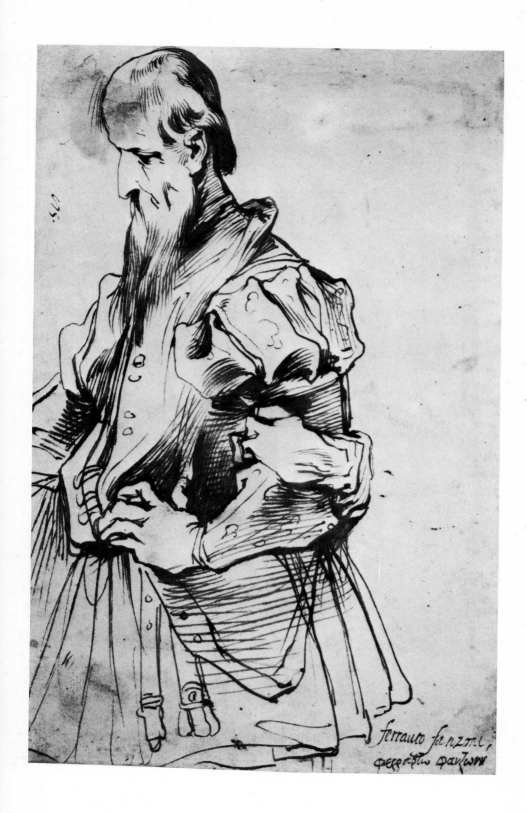

ferrauto fanzini,
φερραϋτω φαντιννν

230
LIEVEN MEHUS, known as LIVIO MEUS
(1630-1691)

SHEET OF CARICATURE HEADS
Pen and brown wash. 263:196
Signed (?) with monogram, and inscribed *Livio Meus.*

Collection: Reynolds
1948-4-10-330

231
AGOSTINO CARRACCI
(1557-1602)

SHEET OF CARICATURE PROFILES
Pen and brown ink. 196:135

Collections: Richardson; West
Pp. 3-11, bequeathed by Richard Payne Knight in 1824

232
GIOVANNI FRANCESCO BARBIERI, called IL GUERCINO
(1591-1661)

CARICATURE GROUP OF A MAN AND WOMAN
Pen and brown ink. 254:200

Ff. 2-139, bequeathed by the Rev. C. M. Cracherode in 1799
Transparency PD 67

233
ANTONIO MARIA ZANETTI
(c. 1680-1757)

CARICATURE OF A MAN HOLDING A PICTURE
Pen and brown ink. 185:130

Collection: Hone
1872-10-12-3326

234
ANTONIO MARIA ZANETTI
(c. 1680-1757)

AN OLD MAN LED BY ANOTHER MAN HOLDING A LANTERN
Pen and brown ink. 202:138
Inscribed on the back: *Caricat^a di mano di Anton maria Zanetti, q^to Giolamo Veneziano,* and on the old mount: *It is Himself, light home by his man; from seeing, probably, some Parmeggianos with a brother virtuoso, of which he had himself a large & well-chosen collection, & which he perfectly well understood, Tasted the Beauties, and admirably imitated; both in copying, of which he has published an elegant and valuable Book, & in his own Invention, of which I have a Rich Proof, which he drew with Red chalk & a Pen in my Library in The Year 21 or 22. I have not seen him since, but this Drawing is so perfectly his stooping, shambling figure & gait, even then; much more, above [illegible] years after, when he was a confirm'd Old Man, That I see him & know him again, as if Present; and will swear to his Nose & knee, and his Eternal length of foot.*

Some friends of mine lately come from Venice (long since my writing the above) knew his caricatura *immediately both to be Him and His. They told me, He frequently stood with a Drol* Caricatura *of Himself instead of his name.*

1851-3-8-1101

235
ANTONIO MARIA ZANETTI
(c. 1680-1757)

CARICATURE OF CARLO FARINELLI
Pen and brown ink. 254:143

Carlo Farinelli (1705-1782), *castrato* singer. Favourite and, in effect, chief minister of King Philip V of Spain.

1872-10-12-3325
Transparency PD 68

236
PIERLEONE GHEZZI
(1674-1755)

CARICATURE OF SIR THOMAS DEREHAM
Pen and brown ink. 362:244

Collection: Spencer
1893-7-31-10

237
HENRY WILLIAM BUNBURY

A MUSICAL PARTY
Pencil and red chalk. 220:311

1870-5-14-2848

238
PIERLEONE GHEZZI
(1674-1755)

DR. HAY
Pen and brown ink. 362:244
Inscribed: *Dr Hay Cav' Ghezzi,* and on the back:
A Caricature of Dr Hay, an old Scotch travelling Gouverneur.

Dr Hay was evidently a professional 'bear leader', who made a living by conducting young English travellers making the Grand Tour.

Collections: Thane, Barnard, Lawrence, Philipps-Fenwick
1946-7-13-98, presented anonymously

239
JOHN CAWSE
(1779-1862)

CARICATURE OF JOSEPH WILTON
Pen and black ink and grey wash. 255:163
Signed and dated, *1793.*

Joseph Wilton, R.A. (1722-1803), sculptor.

1883-5-12-158

240
NATHANIEL DANCE
(1735-1811)

CARICATURE GROUP OF FIVE MEN
Pen and black ink. 135:155

1898-7-12-94

241
THOMAS ROWLANDSON
(1756-1827)

CARICATURE OF G. M. MOSER
Pen and brown ink. 144:132

George Michael Moser (1704-1783), chaser and enameller. Active in the foundation of the Royal Academy.

1870-5-14-1225

242
JOHN DOWNMAN
(c. 1750-1824)

DR GORHAM
Black chalk and grey wash. 201:133
Signed with initials and dated, *1779,* and inscribed: *The Apothecary Doctor Gorham St Neots Huntingdonshire. The only charicatura I ever drew.*

1962-7-14-29, bequeathed by Iolo Williams

243
KARL von KUBINSKY
(active c. 1790)

CARICATURE OF A CARD-PLAYER
Pen and brown wash. 191:123

1872-10-12-3289

244
JAMES GILLRAY
(1757-1815)

CARICATURE OF KING GEORGE IV (WHEN PRINCE OF WALES)
Pen and brown ink. 154:101
Inscribed: *His Roy¹ Highness.*

Collection: Phillipps-Fenwick
1946-7-13-1205, presented anonymously

245
GEORGE, 1st MARQUESS TOWNSHEND
(1724-1807)

COUNT DE LIPPE
Pen and brown ink. 181:123
Signed, and inscribed as above.

Friedrich Wilhelm Ernst, Count von Schaumburg-Lippe (1724-1777), general. He and Townshend were present at the Battle of Dettingen in 1743. Townshend's retirement from the army in 1750 is said to have been due to his having offended the Commander-in-Chief, the Duke of Cumberland, by his caricatures of him. A full-length portrait of Lippe by Reynolds is in the Royal Collection.

1931-4-13-19

246
JAMES SEYMOUR
(1702-1752)

SIR ROBERT FAGG
Pen and brown ink. 158:123
Signed with initials.

1897-6-15-3

247
RICHARD DOYLE
(1824-1883)

(a) CARDINAL NEWMAN
Pen and black ink. 69:57

John Henry, Cardinal Newman (1801-1890)

(b) THOMAS CARLYLE
Pen and black ink. 59:54

Thomas Carlyle (1795-1881), writer and historian

1886-6-19-68 and 69

248
RICHARD DOYLE
(1824-1883)

(a) JOHN FORSTER
Pen and ink. 128:70

John Forster (1812-1876), writer, best known for his life of Charles Dickens, the novelist (1812-1870).

(b) CHARLES DICKENS AND JOHN FORSTER
Pen and ink. 61:58

(c) SIR HENRY COLE
Pen and ink. 67:70

Sir Henry Cole, K.C.B. (1808-1882), amateur draughtsman and etcher. Secretary of the School of Design, active in the foundation of the South Kensington (now the Victoria and Albert) Museum.

(d) JOHN LEECH AND TOM TAYLOR
Pen and brown ink. 51:64

John Leech (1817-1864), humorous draughtsman and illustrator. Tom Taylor (1817-1880), dramatist and editor of *Punch*.

(e) MARK LEMON AS ROBERT MACAIRE
Pen and brown ink. 97:82

Mark Lemon (1809-1870), playwright and first editor of *Punch*. Robert Macaire was an unscrupulous and resourceful rogue, a character in a French melodrama, *L'Auberge des Adrets*, produced in 1823.

(f) DOUGLAS JERROLD, JOHN FORSTER AND CHARLES DICKENS
Pen and brown ink. 102:90

Douglas Jerrold (1803-1857), humorous writer.

1886-6-19-94, 93, 92, 90, 91 and 95

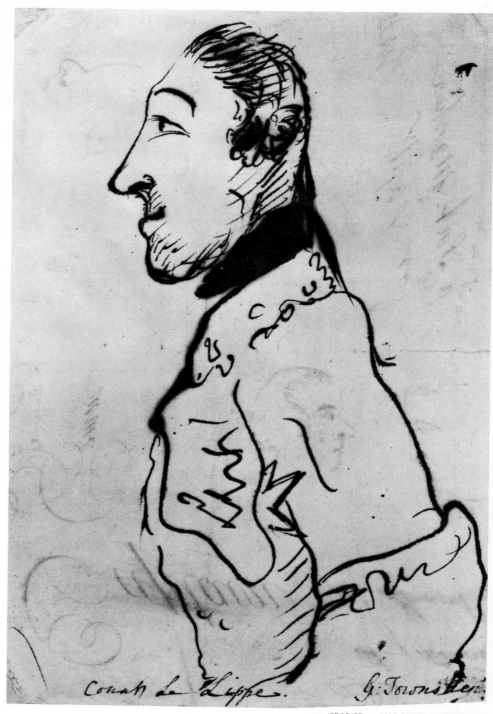

Conah de Lippe. G. Townshend

245 GEORGE 1st MARQUESS TOWNSHEND
COUNT DE LIPPE

249

RICHARD DOYLE
(1824–1883)

(a) MARSHAL PELISSIER
Pen and brown ink. 165:98

(b) M. J. HIGGINS AND MARSHAL PELISSIER
Pen and brown wash. 211:135

Aimable-Jean-Jacques Pelissier (1794–1864), duc de Malakoff and Marshal of France, Commander-in-Chief of the French forces in the Crimean War and French Ambassador in London in 1858/9.

Matthew James Higgins (1810–1868), journalist under the pseudonym of 'Jacob Omnium'.

1886-6-19-83 and 84

250

RICHARD DOYLE
(1824–1883)

(a) LORD DERBY CONFERRING THE D.C.L. ON MR DISRAELI
Pen and black ink over pencil. 57:97
Inscribed as above.

Edward Stanley, 14th Earl of Derby (1799–1869), leader of the Conservative Party and Prime Minister in 1852. Benjamin Disraeli (1804–1888), later Earl of Beaconsfield, Conservative statesman, Chancellor of the Exchequer in the 1852 administration. Lord Derby, as Chancellor of Oxford University, nominated Disraeli for the honorary degree of D.C.L. in 1853. It was generally known that the two, though political allies, were not personally on friendly terms.

(b) LORD JOHN RUSSELL AND BENJAMIN DISRAELI
Pen and black ink over pencil. 115:103

Lord John Russell, later Earl Russell (1792–1878), Whig statesman. Prime Minister 1865–66.

1886-6-19-88 and 89

251

ALFRED EDWARD CHALON
(1780–1860)

STUDY AT THE BRITISH INSTITUTION 1805
Pen and brown ink and watercolour. 316:531
Signed with monogram.

The personages are identified, from left to right, as: Henry Howard, James Green, Thomas Rowlandson, Harriet A. E. Jackson, Douglas Guest, Miss Fanny Reinagle, Nicholas Pocock, William Dixon, A. Celli, Miss M. Hays, Benjamin West, Unknown, Samuel William Reynolds, Miss Charlotte Reinagle, Valentine Green, John James Masquerier.

1879-6-14-757

252

ALFRED EDWARD CHALON
(1780–1860)

STUDY AT THE BRITISH INSTITUTION 1806
Pen and brown ink and watercolour. 324:531
Signed with monogram, and previously inscribed: *The Porter "it's four o'clock, ladies and gentlemen".* The personages are identified, from left to right, as: Robert Dighton, Unknown, Richard Sass, Mrs Mary Green, John Linnell, William Mulready, Unknown, G. W. Gent, Hugh Irvin, Richard Reinagle, George Dawe, Alfred Edward Chalon, Michael Sharpe, Frederick Christian Lewis, George Samuel, Thomas Medland, Miss Pyne, Miss Dawe.

The British Institution for Promoting the Fine Arts in the United Kingdom was founded in 1805, and held its first exhibition of works by living artists in the following year.

1879-6-14-758

253

SIR MAX BEERBOHM
(1872–1956)

AN AUDITION
Indian ink and watercolour over black chalk. 414:449
Signed and dated, *1908*.

The diminutive figure at the piano is identified in the artist's hand as 'Tosti' (Paolo Tosti, composer of sentimental ballads, 1846-1916).

1958-5-14-6, presented by the Contemporary Art Society

SIR MAX BEERBOHM
(1872-1956)

SET OF FIVE DRAWINGS ILLUSTRATING A FRENCH NEWSPAPER ARTICLE ON WALTER SICKERT
Pen and indian ink and grey wash

Each signed.

254
'un dandy singulier' 288:195

255
(a) 'il est avec Whistler le peintre de la nuit' 193:312

(b) 'Les visiteurs, au premier aspect, sont déconcertés par l'uniformité des tons noirâtres repandus dans ses toiles' 201:318

256
M. Jacques Blanche, si sévère pour ses confrères, s'est toujours montré pour le plus fort des disciples et des armis de James MacNeil Whistler d'une parfaite et fraternelle équité'. The chorus of onlookers in the background are exclaiming 'et c'est a qu'on appelle l'équité!' 316:200

257
'lit avec délices Martial dans le texte' 199:294

The article, illustrated by Louis Vauxelles, appeared in *Gil Blas* on January 12, 1907. It was a review of an exhibition of Sickert's paintings at the Galerie Bernheim, Paris.

1914-9-10-4, 3, 2, 1 and 5

258
HENRY TONKS
(1862-1937)

D. S. MACCOLL AS DON QUIXOTE AND WILLIAM ROTHENSTEIN AS SANCHO PANZA
Watercolour over pencil. 249:422

D. S. MacColl (1859-1948), art critic and Director of the Tate Gallery, and William Rothenstein (1872-1945), painter and portrait draughtsman. The drawing alludes to their campaign, c. 1903, to reform the administration of the Chantrey Bequest.

1938-1-8-2

259
EDMUND BLAMPIED
(1886-1966)

THE MAHATMA GANDHI RECEIVING THE FREEDOM OF EPSOM
Black, brown and pink crayon and brown wash. 369:507
Signed and dated, *1931*, and inscribed: *Nonsense drawing*.

1933-4-8-131

ACTORS, SINGERS, ETC.

260
GEORGE VERTUE
(1684-1756)

WILLIAM PENKETHMAN
Pen and ink and red chalk. 298:225

Inscribed: *DON CHOLERI[C]
SNAP SHORT[O] DE TESTY.*

William Penkethman (d. 1725), comedian, as Don Lewis in Colley Cibber's *Love makes a Man*. He is wearing the pseudo sixteenth-century costume then thought appropriate to plays set in the Middle Ages or in Spain. 'Don Choleric Snap Short de Testy' is the name by which Don Lewis is referred to by his disrespectful nephew.

1910-2-18-56, presented by Mrs Robert Low

261
JOHN GIBSON
(1790-1866)

JOHN PHILIP KEMBLE
Pencil. 308:230
Signed.

John Philip Kemble (1757-1823), actor and younger brother of Mrs Siddons. 'A stately rather than impassioned actor, he excelled in classical parts, especially Coriolanus'.

1894-5-16-10

262
FRANCIS COTES
(1725-1770)

SAMUEL FOOTE AS MRS COLE IN 'THE MINOR'
Black, red, blue and white chalk on blue paper. 399:284

Samuel Foote (1720-1777), comic actor and playwright. *The Minor*, a satire on the Methodists, produced in London in 1760, is said to be his best comedy.

1859-2-12-19

263
JOHN HAYTER
(1800-1891)

MRS SIDDONS
Black and red chalk. 152:116
Dated 1826.

Sarah Siddons, born Sarah Kemble (1755-1831), one of the greatest of English tragic actresses. Sister of John Philip and Charles Kemble.

1913-5-28-39

264
SAMUEL DE WILDE
(1748-1832)

CHARLES KEMBLE
Pencil, red chalk and brown wash. 182:146
Signed and dated, *July 1817.*

Charles Kemble (1775-1854), actor 'eminently picturesque in tragic characters'. A younger brother of Mrs Siddons.

1913-5-28-22

265
EDWARD FRANCIS BURNEY
(1760-1848)

DAVID GARRICK
Pencil and grey wash. 222:181

David Garrick (1717-1779), actor, excelling in both tragedy and comedy.

Ee 3-71

266
JOHN NIXON
(c. 1760-1818)

NELLIE FARREN
Greyish-brown and pink wash. 130:93
Signed with initials.

Elizabeth Farren (1759?-1829), comic actress. Married in 1797 the 12th Earl of Derby.

1909-4-6-39

267
ALFRED EDWARD CHALON
(1780-1860)

ANTONIO TAMBURINI
Watercolour. 343:228

Antonio Tamburini (1800-1876), the most distinguished baritone singer of his day. He is here represented in the part of Sir Riccardo Forth in Bellini's *I Puritani*, probably in the London production of 1835.

1922-10-17-6

268
ALFRED EDWARD CHALON
(1780-1860)

MADAME DE GERVILLIERS DANS FANCHON LA VEILLEUSE
Watercolour. 358:224
Inscribed as above and dated, *1829.*

1922-10-17-2
Transparency PD 65

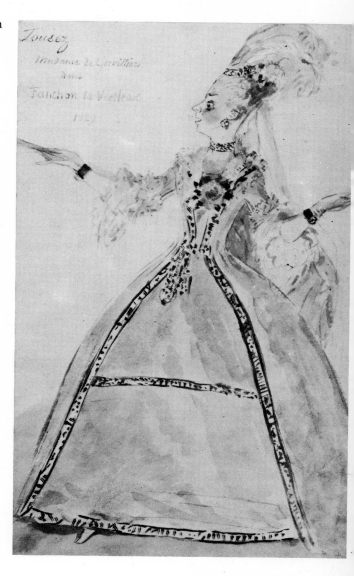

268 ALFRED EDWARD CHALON
MADAME DE GERVILLIE DANS FANCHON LA VEILLEUSE

269
SAMUEL DE WILDE
(1748-1832)

MR DE CAMP AS COUPEE IN 'THE VIRGIN UNMASK'D'
Pencil, red chalk, and watercolour. 359:226
Inscribed as above and signed and dated, *1806*.

M. 32-4

270
JOHN HAYTER
(1800-1891)

MARIA MALIBRAN
Black chalk with blue wash and white bodycolour.
227:177

Maria Malibran (1808-1836), mezzo-contralto
prima donna.

1913-5-28-38

271
FREDERICK SANDYS
(1832-1904)

MISS HERBERT
Pencil, touched with white bodycolour, on pinkish-buff paper. 410:160
Signed with monogram.

Ruth Herbert (c. 1833-1921), actress, one of D.
G. Rossetti's favourite models. This drawing is
said to have been made in 1860.

1910-10-13-25

272
THEODORE HOOK
(1788-1841)

MICHAEL KELLY
Pen and indian ink. 78:63

Michael Kelly (c.1764-1826), Irish actor and
singer.

1879-6-14-763

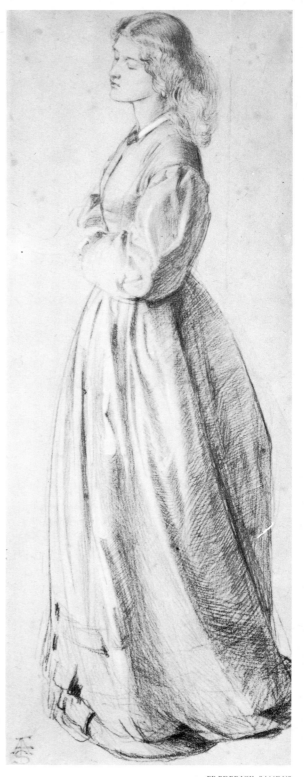

271 FREDERICK SANDYS
MISS HERBERT

273
SAMUEL DE WILDE
(1748-1832)

MASTER BETTY AS ORESTES IN 'THE DISTREST MOTHER'
Pencil, red chalk, and watercolour. 366:225
Signed and dated, *1805.*

William Betty (1791-1874), actor and infant prodigy, known as 'The Young Roscius'. He made his first appearance on the stage at the age of eight.

1882-5-13-23

274
ALFRED SOHN-RETHEL
(b. 1875)

SARAH BERNHARDT AS HAMLET
Pencil. 251:175

Signed and inscribed: *Paris.*

Sarah Bernhardt (1845-1923), French *tragedienne.* Her *Hamlet,* with herself in the title role, was produced in Paris in 1899.

1938-2-12-8, presented by H. H. Newton
Transparency PD 66

275
SIR WILLIAM RUSSELL FLINT
(1880-1969)

ERNEST THESIGER AS VOLTAIRE
Brown chalk on old French tinted (brownish-pink) paper. 365:242
Signed.

Ernest Thesiger (1879-1961), actor. Took the part of Voltaire in Eric Linklater's play *Crisis in Heaven,* in 1944.

1956-12-8-4, presented by the Artist

276
ALFRED EDWARD CHALON
(1780-1860)

CERVETTO AGED 86
Pink wash over pencil. 348:232
Dated *March 8 1832.*

James Cervetto (1746-1837), cellist.

1922-10-17-5

277
CHARLES F. TOMKINS
(1798-1844)

LUIGI LABLACHE
Brush and black ink over pencil. 287:207

Luigi Lablache (1794-1856), Italian singer.

1904-6-17-1, presented by Mrs Robert Barclay

278
PHIL MAY
(1864-1903)

TWO SKETCHES OF JOSEF HOLLMANN
Pen and black ink over pencil. 290:240 and 275:236

Josef Hollmann (b. 1852), Dutch cellist.

1920-6-12-20 and 21

XVI-XX CENTURY: ENGLISH

(some drawings of other schools from XVIII century onwards

279
WILLIAM FAITHORNE
(1616?-1691)

SIR EDMUND KING
Red and black chalk, watercolour and bodycolour.
189:142

Sir Edmund King (1629-1704), physician and surgeon, Fellow of the Royal Society. Physician to King Charles II.

1847-3-26-5
Transparency PD 24

280
RICHARD GIBSON
(1615-1690)

A LITTLE GIRL
Black, red and white chalk on pale brown paper.
252:199
Signed with monogram and dated, *1669.*

1900-7-17-41

281
MICHAEL DAHL
(1659-1753)

A YOUNG MAN
Black, red and white chalk on buff paper. 269:189

1914-6-15-1
Transparency PD 25

282
SIR PETER LELY
(1618-1680)

THE DUKE OF LAUDERDALE

Black chalk and stump, heightened with white, on buff paper. 181:168
Inscribed in a later hand: *D Lauderdale.*

John Maitland, 2nd Earl and 1st (and last) Duke of Lauderdale (1616-1687). Statesman, noted for his great ability, his brutal force, and his debauched character. He was the 'L' in the Cabal. The drawing probably dates from c. 1672/3.

1874-8-8-2263

283
SIR PETER LELY
(1618-1680)

SIR CHARLES COTTERELL
Oil on paper. 203:169

Sir Charles Cotterell (1615-1701), Master of Ceremonies to Charles I and Charles II. He is wearing the gold chain and badge of his office, with which he was invested in 1661. This portrait seems to be a reduction of a larger oil painting rather than a preliminary study; but its quality is high enough for Lely himself.

1881-6-11-167

284
ISAAC OLIVER
(1556?-1617)

A LADY SEATED WITH HER ARMS CROSSED
Metalpoint on yellowish prepared paper. 104:73

Collection: Richardson
1952-11-22-1

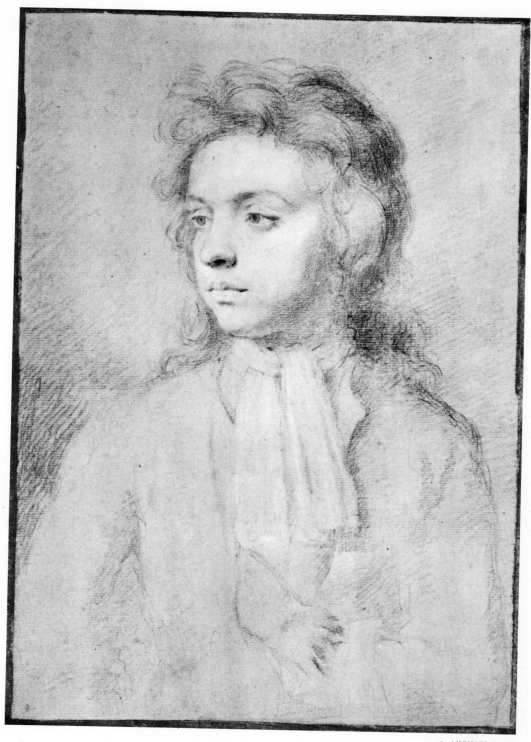

281 MICHAEL DAHL
A YOUNG MAN

285
SIR PETER LELY
(1618-1680)

HEAD AND SHOULDERS OF A LADY
Black, red and white chalk on brownish-grey paper.
245:184
Signed with monogram.

1866-7-14-36
Transparency PD 26

286
CHARLES BEALE
(1660-1726?)

'SU: JAXON'
Red chalk. 206:160

One of a large number of similar portrait studies in red chalk in the British Museum and the Pierpont Morgan Library, New York.

Gg. 4. W. 5-39, bequeathed by the Rev. C. M. Cracherode in 1799

287
SIR GODFREY KNELLER
(1646/49-1723)

HEAD OF A YOUNG MAN
Black and white chalk on buff paper. 278:228

1870-10-8-2378

288
WILLIAM HOGARTH
(1697-1764)

STUDY OF A SLEEPING CHILD
Black and red chalk on grey paper. 229:276

1895-12-14-1

289
ENGLISH SCHOOL, c. 1740 (traditionally attributed to William Hogarth)

THOMAS SMITH

Black chalk. 184:138
Inscribed on the wall: *past 4 o'clock in ye morg*, and on the pages of the open ledger: *Receipts of a Gala Night* and *Vauxhall*.

Thomas Smith was the bookkeeper at Vauxhall Gardens. Hogarth engraved the entrance tickets for Vauxhall and painted several pictures to decorate the boxes. The connexion with Vauxhall no doubt suggested the attribution, which is not supported by the handling of the drawing itself.

1928-17-4-13

290
WILLIAM WISSING
(1656-1687)

A LADY SEATED
Black chalk. 474:319

The attribution to Wissing presumably goes back to the time of Sir Hans Sloane, in the first half of the eighteenth century. No other drawings by him are known which might substantiate it. This type of intimate portrait study was common in Holland, but is found in England only in the drawings of Charles Beale.

5214-68, bequeathed by Sir Hans Sloane in 1753

291
PETER TILLEMANS
(1684-1734)

THOMAS COOK
Watercolour. 217:312
Signed and dated *1725*, and inscribed: *Tho. Cook of Thoresby aged 85.*

1881-6-11-198

292
WILLIAM HOGARTH
(1697-1764)

A YOUNG WOMAN
Oil on canvas. 98:74

Datable probably in the 1720's or 1730's.

1861-8-10-28

293
THOMAS GAINSBOROUGH
(1727-1788)

A LADY STANDING
Black chalk, heightened with white, on buff paper.
494:313

The costume suggests a date towards the end of the 1780's.

1910-2-12-250, bequeathed by George Salting

294
THOMAS GAINSBOROUGH
(1727-1788)

A LADY SEATED

Black chalk touched with white bodycolour on grey paper. 311:234

The coiffure suggests a date c. 1775-80.

1895-7-25-1
Transparency PD 27

295
THOMAS GAINSBOROUGH
(1727-1788)

STUDY FOR A PORTRAIT OF A LADY
Black chalk on grey paper. 465:331

A costume-study, perhaps from a lay-figure. The dress suggests a date c. 1765-70.

1855-7-14-70

291 PETER TILEMANS
THOMAS COOK

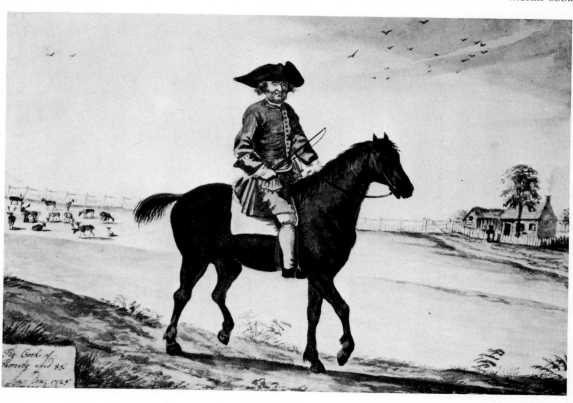

296
THOMAS GAINSBOROUGH
(1727-1788)

MRS PHILIP THICKNESSE
Pencil and watercolour. 335:257

A study for the portrait, painted in 1760 and now in Cincinnati.

1894-6-12-11

297
THOMAS GAINSBOROUGH
(1727-1788)

STUDY FOR A GROUP PORTRAIT OF A MUSICAL PARTY
Red chalk. 241:323

The figures have not been identified, but it is possible that the scene is the Linleys' house in Bath. The coiffure of the girl on the left suggests a date c. 1770.

1889-7-24-371

298
LUIS PARET Y ALCAZAR
(1746-1799)

QUEEN MARIA LOUISA OF SPAIN
Pencil and grey wash. 350:243

Maria Louisa Farnese (1751-1819), wife of King Charles IV of Spain.

1890-12-9-49

299
HENRI-PIERRE DANLOUX
(1753-1809)

JEAN-FRANÇOIS LA MARCHE (?)
Black chalk. 377:264

This has been identified as a portrait of Jean-François La Marche (1729-1806), created Bishop of St Pol-de-Leon in 1772. A staunch Royalist, he escaped to London in 1791, where he devoted himself to the welfare of his fellow-émigrés. He was a friend of Edmund Burke.

1910-2-18-9

300
LOUIS CARMONTELLE
(1717-1806)

LE COUREUR DE ST CLOUD
Red and black chalk with shades of green wash. 268:157

'Coureur' is defined in Littré's dictionary as a private servant employed to carry letters and messages.

1904-6-14-3

301
THOMAS KERRICH
(1748-1828)

THE REV. WILLIAM COLE
Black and red chalk. 450:301

William Cole (1714-1782), antiquarian of Cambridge, friend and correspondent of Horace Walpole. Kerrich, University Librarian at Cambridge and fellow of Magdalene College, was also a distinguished antiquarian.

1972 U 536

302
MOSES HAUGHTON II
(c. 1772-after 1848)

JOSEPH PRIESTLEY
Brown wash over pencil and red chalk. 187:172 (arched top)

Joseph Priestley (1733-1804), theologian, controversialist, and man of science. Pioneer of research into electricity, and discoverer of oxygen.

1888-12-11-5

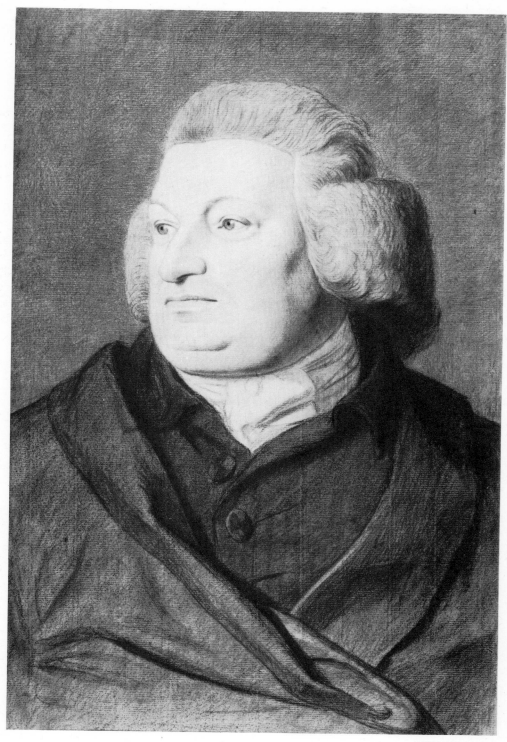

301 THOMAS KERKICH
THE REV. WILLIAM COLE

303
THOMAS HOLLOWAY
(1748–1827)

JOHN HOWARD
Black chalk. 130:106

John Howard (1726?–1790), philanthropist, best known for his reform of the prison system.

1939-3-3-5

304
ANTOINE WATTEAU
(1684–1721)

AN ABBÉ
Black and red chalk. 138:98
The inscription on the back is part of a doctor's prescription for a cough, and it has been suggested that this may be a portrait of the artist's doctor.

1893-12-12-2

305
GABRIEL DE ST AUBIN
(1724–1780)

CHARLES–GERMAIN DE ST AUBIN
Black chalk, with touches of red chalk. 111:90

Charles-Germain de St Aubin (1721–1786), ornamental draughtsman and engraver. Elder brother of Gabriel de St Aubin.

1897-6-15-16

306
GAETANO GANDOLFI
(1734–1802)

A YOUNG WOMAN READING
Black and red chalk. 294:205

Collection: Phillipps-Fenwick
1946-7-13-1321, presented anonymously

307
JEAN-AUGUSTE-DOMINIQUE INGRES
(1780–1867)

MADAME D'HAUSSONVILLE
Black chalk. 351:174

Louise de Broglie, married in 1836 to Vicomte Othenin d'Haussonville. A study for the portrait now in the Frick Collection, New York, painted in 1845.

1886-4-10-31

308
HENRY FUSELI
(1741–1825)

HEAD OF A LADY
Black chalk, with brown and grey wash. 306:188

1902-4-14-1

309
JEAN-AUGUSTE-DOMINIQUE INGRES
(1780–1867)

CHARLES HAYARD AND HIS DAUGHTER,
MARGUERITE
Pencil. 307:229
Signed and dated, *Rome 1815,* and inscribed '*à Madame Hayard*'.

1968-2-10-19, bequeathed by César Mange de Hauke

310
JEAN-LOUIS-ANDRÉ-THÉODORE GÉRICAULT
(1781–1824)

PORTRAIT–GROUP OF A MOTHER AND THREE
CHILDREN
Pencil. 241:288

The wife and children of the shoemaker in whose

house Géricault lodged on his visit to London in 1821. A lithograph of it in reverse was published in London.

1888-6-19-19

311
JEAN-AUGUSTE-DOMINIQUE INGRES
(1780-1867)

SIR JOHN HAY AND HIS SISTER, MARY
Pencil. 292:222
Signed and dated, *Rome 1816.*

Sir John Hay, 6th Baronet of Smithfield (1788-1838) and his sister, later Mrs Forbes.

1938-8-17-1, presented by the National Art-Collections Fund

312
JOHN FLAXMAN
(1755-1826)

MRS MATHEW
Pencil. 242:216

Henrietta, wife of the Rev. Anthony Mathew (1733-1824). She was one of the 'Blue Stocking' circle, and an early patron of Flaxman and William Blake.

1888-6-12-105

313
SIR THOMAS LAWRENCE
(1769-1830)

COUNTESS ROZALIA RZEWUSKA
Black chalk with touches of pink wash. 413:264

Countess Rozalia Lubomirska (1788-1865), wife of Wenceslaus Rzewuski. A label formerly on the drawing stated that Lawrence made the drawing in Vienna, where he was in 1818/19.

1900-7-17-57

314
PELTRO WILLIAM TOMKINS
(1759-1840)

PRINCESS CHARLOTTE AUGUSTA
Black and red chalk, watercolour and bodycolour. 272:188

Charlotte Augusta (1766-1828), eldest daughter of King George III and Queen Charlotte, married in 1797 the Hereditary Prince (later Duke, and in 1806 King) of Würtemberg.

1890-5-12-141

315
JOHN DOWNMAN
(c. 1750-1824)

MISS ABBOTT
Black chalk and stump and watercolour. 202:167 (oval)
Inscribed after the sitter's name: *Original. Admired as most amiable.*

1884-4-26-51

316
RICHARD COSWAY
(1742-1821)

MRS PLOWDEN
Pencil and (on the face only) watercolour. 223:143

1901-4-17-15

317
JOHN HOPPNER
(1758-1810)

MARY ROBINSON ('PERDITA')
Black and red chalk. 267:225
Inscribed: *Mrs Robinson – P. of Wales.*

Mary Darby, later Robinson (1758-1800), actress and poetess, and for a short time an early mistress of the Prince of Wales (later King George IV).

The name Perdita, by which she was known, came from the part in Shakespeare's *Winter's Tale,* in which she was a notable success.

1868-3-28-342

318
JOHN SINGLETON COPLEY
(1757-1815)

THE EARL OF MANSFIELD
Black chalk, heightened with white, on blue paper.
257:267

William Murray, 1st Earl of Mansfield (1705-1793), Lord Chief Justice of England from 1756. A study for the portrait painted in 1783 and now in the National Portrait Gallery.

1913-5-28-20

319
DANIEL GARDNER
(1750?-1805)

THE DUKE OF NORFOLK
Pastel. 240:192 (oval)

Charles Howard, 11th Duke of Norfolk (1746-1815), Whig politician.

1914-4-6-8
Transparency PD 29

320
NATHANIEL DANCE
(1734-1811)

EARL CAMDEN
Black chalk, touched with red and white chalk, on blue paper. 365:276

Charles Pratt, 1st Earl Camden (1714-1794), Lord Chancellor from 1766 to 1770. A study for a portrait of which there are two versions, one belonging to the Marquess Camden and the other in the National Portrait Gallery.

1905-10-19-14

321
JOHN FIELD
(1771-after 1846)

TWO SILHOUETTES OF WILLIAM PITT (ONE COR-RECTED BY HIS NIECE, LADY HESTER STANHOPE)
Indian ink. 87:72 and 88:73 (both oval)

William Pitt (1759-1806), Prime Minister 1783 to 1800 and from 1804 until his death. A note accompanying the pair of silhouettes, signed 'J. Field, Profilist, 2 Strand', explains that they were made from the well-known bust by Joseph Nollekens, itself based on a death-mask which 'required the utmost study & attention before it was permitted (by a Committee of Taste) to come before the World, the agonies of Death were so strongly developed in the expression'. He submitted the silhouette to Lady Hester Stanhope, who 'did not approve of *any* of the likenesses done of him! The one from Mr Nolleken's bust she received from me and placing it on the table before her took up her Pen Knife & in a few seconds returned it to me in its present scratched state, saying at the same time, "there, that is more like what he was, but don't show it to anyone" . . . the profile is precisely in the same state I received it from her hand'.

1846-4-25-21 and 22, presented by the Artist

322
EDWARD FRANCIS BURNEY
(1760-1848)

HEAD AND SHOULDERS OF AN ELDERLY MAN IN PROFILE
Pencil and grey wash. 92:70 (size of oval).

Evidently inspired by the portrait medallions produced in the later eighteenth century by Tassie and by Wedgewood, in which the head is modelled in low relief against a dark background.

1958-12-29-6

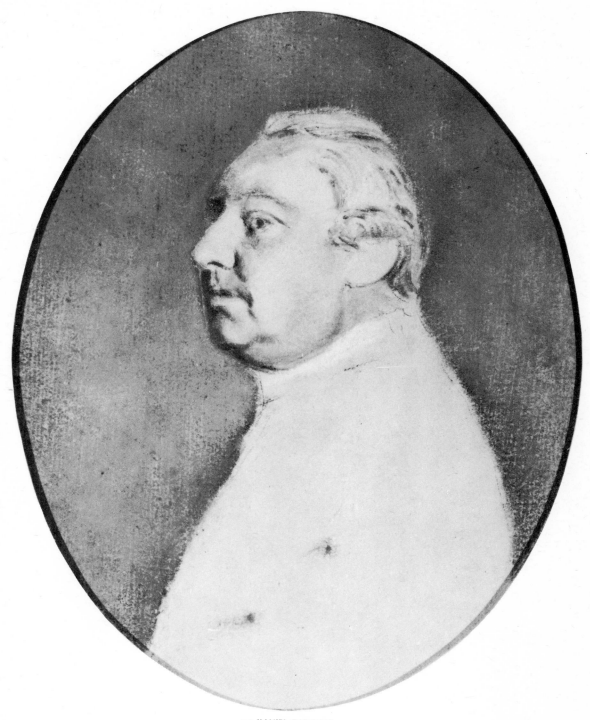

319 DANIEL GARDNER
THE DUKE OF NORFOLK

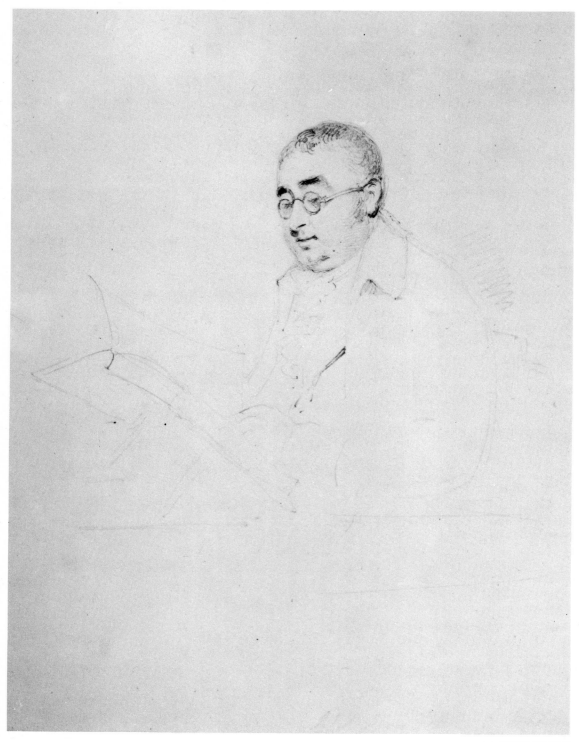

323 HENRY EDRIDGE
CHARLES JAMES FOX

323
HENRY EDRIDGE
(1769-1821)

CHARLES JAMES FOX
Pencil. 211:162
Inscribed: *at St Annes.*

Charles James Fox (1749-1806), Whig statesman.
The drawing must date from the later years of
Fox's life, when he tended to live in retirement at
his country house, St Anne's, near Weybridge.

1891-5-11-41

324
HENRY EDRIDGE
(1769-1821)

EARL SPENCER
Pencil and (the head only) watercolour. 320:226

George John, 2nd Earl Spencer, K.G. (1758-1834),
First Lord of the Admiralty, 1794-1801, Home
Secretary, 1806-7. Best remembered as a book-
collector. He formed the famous Althorp Library,
now in the John Rylands Library at Manchester.

1891-5-11-40

325
FRANCISCO GOYA
(1746-1828)

THE DUKE OF WELLINGTON
Red chalk. 235:178

Inscribed: *Lord Weling" estudio p.ª el retrato
equestre qᶜ pinto Goya.*

This drawing, made in the summer of 1814, was
the basis of the equestrian portrait of the Duke at
Apsley House, and the head-and-shoulders one
now in the National Gallery. It seems originally
to have been made for an etching, which was
never carried out.

1862-7-12-185
Transparency PD 69

326
LIEUTENANT ANDREW MOTZ SKENE, R.N.
(d. 1849)

NAPOLEON I ON BOARD H.M.S. NORTHUMBERLAND
Watercolour. 258:362

H.M.S. Northumberland was the ship that took
Napoleon from Plymouth to St Helena in 1815.
Lieut. Skene was presumably one of the ship's
company, since there are some views of St Helena
by him also in the collection.

1884-11-8-13

327
ANDREA APPIANI
(1754-1817)

NAPOLEON BONAPARTE
Black and red chalk, with red and grey wash. 400:310

Presumably made in Milan in the course of the
Italian campaign of 1796-7, when Napoleon was
aged about 28.

1926-4-12-80
Transparency PD 28

328
PHILIP JAMES DE LOUTHERBOURG
(1740-1812)

(a) THOMAS RAMSEY
 Watercolour. 170:117
 Inscribed: *5 feet 8 inches 36 [years old] – one of
 the seamen who boarded the San Josef*
 Transparency PD 32

(b) MR CRESSE; A SEPARATE STUDY OF A BOAT-
 SWAIN'S WHISTLE
 Watercolour. 173:118
 Inscribed: *Boatswain. Venerable. 1797. Boat-
 swain's call silver.*

The *Venerable* was Admiral Duncan's flagship at
the Battle of Camperdown (11 Oct 1797), and

the drawing of her boatswain was no doubt made in connexion with de Loutherbourg's large painting of the battle. The *San Josef* was one of the Spanish ships captured at the battle of Cape St Vincent earlier in the same year.

1882-3-11-1138 and 1140

329
JOHN SMART
(1741-1811)

MAJOR ROBSON
Pencil. 226:204

Signed and dated, *Sept. 1794, St Helena.*

1937-12-11-5

330
PHILIP JAMES DE LOUTHERBOURG
(1740-1812)

SIR WILLIAM CONGREVE
Watercolour. 204:128

Sir William Congreve (d. 1812), Lieutenant-General, Colonel Commandant of the Royal Artillery. Created Baronet, 1812. His son, also Sir William Congreve (1772-1828) and an artilleryman, was the inventor of the 'Congreve Rocket'. The drawing is a study for the figure of the General in de Loutherbourg's painting of *The Duke of York's Grand Attack on Valenciennes,* commissioned in 1793.

1851-9-1-708, presented by William Smith

331
THOMAS STOTHARD
(1755-1834)

(a) SIR SIDNEY SMITH
Pencil. 96:68

Admiral Sir Sidney Smith (1764-1840), famous for his defence of Acre in 1799, which decisively checked Napoleon's plans to conquer the Near East.

(b) A SEAMAN ON BOARD H.M.S. VICTORY
Pencil. 74:66

1885-5-9-1403 and 1404

332
BRYAN EDWARD DUPPA
(active 1835-53)

'CAPTAIN' BECHER
Pencil and yellow, blue and red chalk, and white bodycolour. 348:257

William Martin Becher (1797-1864), amateur steeplechase rider, who gave his name to Becher's Brook at Aintree, into which he fell while riding in the first Grand National, in 1839. He held the honorary rank of Captain in the Hertfordshire Yeomanry.

1935-10-12-1

333
JAMES WARD
(1769-1859)

MARY THOMAS
Pencil. 262:370

Signed and dated, *Sept. 2 1807* and inscribed: *Mary Thomas, of Tanvalt near Barmouth, the fasting woman, 82 years old, been in bed since she was 15, 10 years without tasting anything to eat or drink.*

1885-6-13-45

334
GEORGE DANCE
(1741-1825)

THE CHEVALIER D'ÉON
Black chalk and watercolour. 251:192
Signed and dated, *May 26th 1793.*

Charles - Geneviève - Louis - Auguste - André - Timothée d'Éon de Beaumont (1728-1810),

French diplomatic agent and adventurer. He was in the habit of wearing women's clothes, and his true sex was a matter of speculation and the subject of wagers. In 1774 he accepted a pension from the French government on condition that he henceforth dressed as a woman. In 1785 he came to live in England. He was a skilful fencer, and after the outbreak of the French Revolution, which brought his pension to an end, he supported himself by giving – still in his female dress – exhibitions of fencing. After his death, an autopsy revealed that the Chevalier was a man. In the drawing he is wearing a French order, probably that of Our Lady of Mount Carmel.

1898-7-12-19

335
DENIS DIGHTON
(1792-1827)

JOHN BELLINGHAM
Pencil. 293:223
Dated, *May 15th 1812, at the Sessions House, Old Bailey.*

John Bellingham, a timber merchant, was obsessed by a grievance against the British Government for its failure to support him in a dispute with the Russian government. On May 11, 1812, in the lobby of the House of Commons, he shot and killed the Prime Minister, Spencer Perceval. He was tried on 15 May, and, refusing to agree to a defence of insanity, was condemned and hanged.

1937-10-8-20

336
WILLIAM GEORGE SPENCER
(1790-1866)

JEREMIAH BRANDRETH
Indian ink on ivory. 105:75

Mounted with a stipple engraving after the drawing, by E. Scriven, inscribed: *Jeremiah Brandreth,*

as he appeared on his trial for High Treason, at the Special Assizes held in Derby, Oct 16, 1817.

Jeremiah Brandreth, known as the 'Nottingham Captain', framework-knitter and revolutionary. He led an armed insurrection in the neighbourhood of Nottingham in June 1817, for which he was executed in November of the same year.
The artist was father of the philosopher Herbert Spencer.

1935-2-11-1

337
THOMAS WORLIDGE
(1700-1766)

ELIZABETH CANNING
Pencil. 216:159

Elizabeth Canning (1734-1773), a maidservant, in 1753 accused two women of having kidnapped her. After they had been found guilty, and one of them sentenced to death, it was proved that her story was an entire fabrication. She was tried for perjury and transported to New England. The affair caused a great sensation at the time. Josephine Tey's novel, *The Franchise Affair,* is based on it.

1851-3-8-163

338
WILLIAM LOCKE
(1767-1847)

WILLIAM HOOPER
Pen and brown wash. 265:202

Inscribed: *Hooper ye Tinman 1790. Died July 1799 of great distress, carried into St Giles Workhouse by a Chimney Sweeper the Night before.*

William Hooper (d. 1799), prize fighter and pugilist, known as the 'Swell Tinman', born in Bristol. He kept a tinsmith's shop in the Tottenham Court Road and between 1789 and 1794 was the hero of several prizefights. He ended his

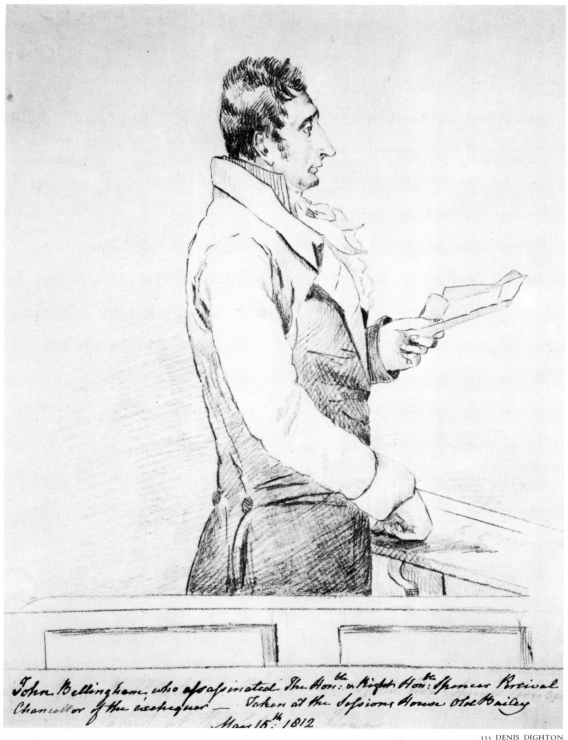

John Bellingham, who assassinated the Hon: & Right Hon: Spencer Percival Chancellor of the exchequer — Taken at the Sessions House Old Bailey May 15th 1812

335 DENIS DIGHTON
JOHN BELLINGHAM

career as 'bully' and bodyguard to his patron, Lord Barrymore.

1962-7-14-54, presented by Iolo Williams

339
G. M. BRIGHTY
(fl. 1809-1827)

GEORGE DYER
Watercolour. 457:322
Signed and dated, *1816*. Inscribed: *George Dyer (Printseller). Exhibited at the Royal Academy 1815 no. 733.*

Presumably a repetition of the portrait exhibited in 1815.

1876-12-9-184

340
LUDWIG EMIL GRIMM
(1790-1863)

ELISABETH BRENTANO
Watercolour. 322:198 (shaped top)
Inscribed on an old label: *Portrait of Bettina von Arnheim [sic] from her own design and sent to Goethe, by Goethe given to Ottilie and by her given to me A.J.* [Anna Jameson].

Elisabeth ('Bettina') Brentano (1785-1859), German authoress, married Ludwig von Arnim 1811. In 1807 she met Goethe and conceived a violent passion for him. They carried on a correspondence which formed the basis of her publication *Goethes Briefwechsel mit einem Kinde,* 1835. The drawing was sent by her to Goethe in 1809.

1885-10-10-6

341
SIR WILLIAM BEECHEY
(1753-1839)

A LADY STANDING
Watercolour. 362:230

1899-6-17-8

342
LUKE CLENNELL
(1781-1840)

(a) LORD HILL
Watercolour over pencil. 168:140
Signed (?)

Rowland Hill, 1st Viscount Hill (1772-1842), one of Wellington's generals in the Peninsular War.

(b) ALDERMAN CHRISTOPHER MAGNAY
Watercolour over pencil. 161:148
Signed (?)

Christopher Magnay (1767-1826), of Wandsworth. Alderman of London 1809-26, Sheriff 1813-14, Lord Mayor, 1821-2.

Both drawings are presumably studies for the painting of the Banquet in honour of the Allied Sovereigns in the Guildhall in June 1814, commissioned from Clennell by the Earl of Bridgwater. 'So much fatigue, vexation, and disappointment was experienced by the artist in assembling the materials for this picture that he became insane'.

1913-5-28-12 and 11

343
THOMAS UWINS
(1782-1857)

TWO PORTRAITS OF DR LANDON
Watercolour. 253:199 and 253:196
Inscribed respectively: *Doctor in Divinity* and *Doctor of Law.*

Dr Whittington Landon (1758-1838), Provost of Worcester College, Oxford, from 1796 to 1838. One of a series of drawings of academical costume, made to illustrate Ackermann's *History of the University of Oxford,* 1814. The inscription 'Doctor of Law' on the right-hand drawing is incorrect: Dr Landon is in fact wearing the full-dress gown of a Doctor of Divinity.

1858-6-26-15 and 14

344

RICHARD DIGHTON
(1785-1880)

PETER ACKLOM
Watercolour. 237:139
Signed.

1939-7-14-135

345

GEORGE CRUIKSHANK
(1792-1878)

MR RUTHERFORD
Watercolour over pencil. Three separate studies of the head in pencil only. 316:251
Inscribed: *Rutherford, pianoforte maker at Messrs Broadwoods.*

1972. U.556

346

SIR GEORGE HAYTER
(1792-1871)

(a) SIR JOHN COPLEY
Black ink and white bodycolour over black chalk on brown paper. 199:136
Inscribed: *Solicitor Genr Sir J. Copley House of Lords Oct 1820.*

John Singleton Copley (1772-1863), son of the American-born portrait painter of the same name. Solicitor-General 1819-24, later Attorney-General, Master of the Rolls, and (as Lord Lyndhurst) three times Lord Chancellor.

(b) QUEEN CAROLINE
Black ink and white bodycolour on brown paper. 206:133
Transparency PD 30

Caroline, Princess of Brunswick (1769-1820), married, in 1795, George Prince of Wales (later King George IV). They separated after the birth of Princess Charlotte of Wales in 1796; and in 1820, shortly after George IV's accession, a Bill (the so-called 'Bill of Pains and Penalties') to dissolve the marriage on the grounds of the Queen's misconduct, was presented to the House of Lords. Copley, as Solicitor-General, was one of the counsel for the prosecution. These drawings are studies for Hayter's large painting of the interior of the House of Lords during the Queen's trial, now in the National Portrait Gallery.

1912-8-7-1 and 2, presented by M. B. Walker

347

JOHN DOYLE, called 'H.B.'
(1797-1868)

KING GEORGE IV AT ASCOT
Pencil. 246:166

1882-12-9-676

348

P. H. STRÖHLING
(fl. c. 1804-26)

THE COUNTESS OF BLESSINGTON
Black chalk. 242:192
Inscribed by the sitter: *M. Blessington drawn by Stroehling in my 23rd year given to Mr E. Landseer in my 50 year 1839,* followed by Landseer's monogram.

Marguerite Power (1789-1849), married in 1818 Charles John Gardiner, 2nd Viscount Mountjoy and 1st Earl of Blessington. Writer, best remembered for her *Journal of the Conversations of Lord Byron,* 1834. Scandalized Society by her long-standing liaison with Count Alfred d'Orsay, the husband of her step-daughter. They maintained a famous literary salon at Gore House, Kensington.

349

JOHN GEORGE FISCHER
(1786-1875)

QUEEN VICTORIA AT THE AGE OF EIGHT MONTHS

Pencil. 213:171

Inscribed: *Sketch for a Miniature Portrait of Princess Victoria. January 1820. Finished on Ivory for the Duchess of Kent.*

Queen Victoria, only child of the Duke and Duchess of Kent, was born on May 19 1819.

1903-4-8-2
Transparency PD 31

350
JOHN LINNELL
(1792-1882)

MRS HARBERT
Watercolour over pencil. 238:165
Signed and dated, *1826.*

1890-5-12-114

351
JAMES WARD
(1769-1859)

A WILTSHIRE PEASANT
Black, red and white chalk on grey paper. 417:291
Signed with monogram, and inscribed on an old label: *A Man in Wiltshire who was in the habit of moving two acres of grass p' day.*

1885-6-13-55

352
JOHN THOMAS SMITH
(1766-1833)

CHRISTOPHER PACK
Pen and brown ink and grey and grey-blue wash. 235:238
Signed and dated (on the print held in the left hand) June 17 1824, and inscribed *Drawn in the print-room of the British Museum.* Inscribed below: *Faithful Christopher Pack, Born at Norwich 12 Aug 1760.*

Perhaps to be identified with the painter Christopher Packe (or Pack), said by the D.N.B. to have been born in Norwich in 1750, and to have practised in Dublin and London. The date of his death is not recorded. Whoever the subject of the drawing was, he was evidently a constant *habitué* of the Printroom.

1956-10-13-2, presented by R. B. Dunwoody

353
WILLIAM BEHNES
(1794-1864)

THOMAS FROGNALL DIBDIN
Black and white chalk. 131:114

Thomas Frognall Dibdin (1776-1847), bibliographer. Author of *The Bibliographical Decameron* and one of the founders of the Roxburghe Club.

1884-10-8-16

354
DANIEL MACLISE
(1806-1870)

LETITIA LANDON
Watercolour. 190:142

Letitia Landon (1802-1838), writer of sentimental verse under the name 'L.E.L.' Described by Disraeli as 'the peculiar poetess of sentimental ladies'-maids, milliners' daughters, Brompton beauties, and Pentonville Aspasias'.

1893-2-27-1, presented by the Rev. James Fraser

355
DANIEL MACLISE
(1806-1870)

SIR WALTER SCOTT
Pencil. 190:142

Signed and dated, *9th Augst 1825,* and inscribed: *Sketched from the Life at Mr Bolster's, Cork.* Inscribed on the *verso: For Mr Bolster with Danl McClise's Respects.*

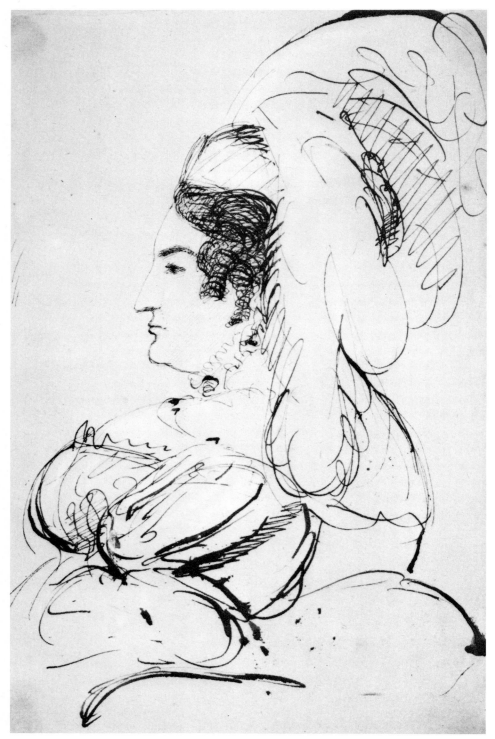

346 SIR GEORGE HAYTER
QUEEN CAROLINE

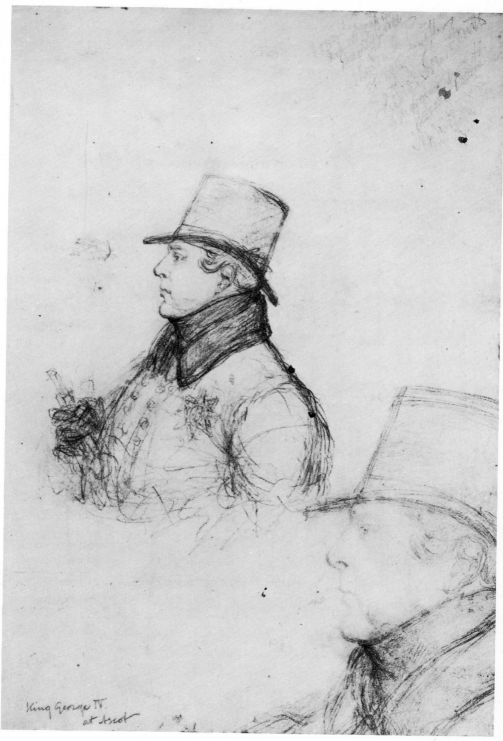

347 JOHN DOYLE
KING GEORGE IV AT ASCOT

Bolster's bookshop was a well-known literary centre in Cork. When Scott visited it during his tour of Ireland in 1825, Maclise made three sketches of him which he worked up into finished drawings, one of which he lithographed.

1907-5-15-27

356
SIR WILLIAM ROSS
(1794-1860)

ISAAC DISRAELI
Pencil and red chalk. 365:251

Isaac Disraeli (1766-1848), miscellaneous writer, author of *Curiosities of Literature*. Father of Benjamin Disraeli.

1910-7-16-5

357
STEPHEN CATTERSON SMITH
(1805-1872)

FRANCIS DOUCE
Pencil. 194:162

Francis Douce (1757-1834), antiquary and collector. Keeper of MSS in the British Museum. Benefactor of the Bodleian Library.

1886-10-12-535

358
RICHARD CATTERMOLE
(1795-1858)

MR AND MRS PORDEN
Pencil. 189:234
Signed.

1889-7-24-16

359
RICHARD WESTALL
(1765-1836)

JOHN IRELAND

Watercolour over pencil. 166:121
Signed.

John Ireland (d. 1808), author. The first biographer of Hogarth.

1864-8-13-299

360
DANIEL MACDONALD
(fl. 1840-53)

Six sketches in pen and black ink made in the House of Lords during the hearing of the Tracy Peerage Case, 4th May 1847.

(a) and (b) *Lord Brougham,* 90:60 and 59:87 respectively
(c) *The Earl of Radnor,* 89:58
(d) unidentified, 90:57
(e) *Lord Sudeley,* 89:58
(f) *Dela . . . The Witness,* 89:60

Henry Brougham, 1st Lord Brougham and Vaux (1778-1868), Lord Chancellor 1830-34; Charles Hanbury-Tracy, 1st Lord Sudeley (1777-1858); William Pleydell-Bouverie, 3rd Earl of Radnor (1779-1869).

1903-12-21-10, 8, 13, 11, 9, 12

361
WILLIAM MULREADY
(1786-1863)

JOHN SHEEPSHANKS AND HIS MAIDSERVANT
Pen and brown wash on blue paper. 386:341

John Sheepshanks (1787-1863), art collector and patron, and public benefactor. After selling his important collection of Dutch and Flemish etchings in 1836 (it was eventually bought by the British Museum) he formed a collection of contemporary British paintings which he presented to the Nation in 1857 (now in the Victoria & Albert Museum).

The drawing is a study for the painting of c. 1832, now in the Victoria & Albert Museum.

364 JOHN DOYLE
THE DUKE OF WELLINGTON RETURNING FROM A REVIEW

Originally the two figures were closer together: the drawing was cut up and they were pasted on to a larger sheet, on which the background was redrawn.
1864-5-14-6

362
RICHARD DIGHTON
(1785-1880)

TWO GENTLEMEN
Watercolour. 275:119
1867-3-9-1146
Transparency PD 35

363
SIR DAVID WILKIE
(1785-1841)

THE DUKE OF WELLINGTON AS CHANCELLOR OF THE UNIVERSITY OF OXFORD
Black chalk. 222:168

Made during the Duke's installation as Chancellor in 1834.

1885-5-9-1654

364
JOHN DOYLE, called 'H.B.'
(1797-1868)

'THE DUKE OF WELLINGTON RETURNING FROM A REVIEW'
Pencil. 277:400
Inscribed as above.

1882-12-9-692

97

365
CHARLES ROBERT LESLIE
(1794-1859)

THE DUKE OF WELLINGTON
Pencil and watercolour. 358:172

A study for the small painting, now at Apsley House, of the Duke contemplating a bust of Napoleon.

1860-4-14-447
Transparency PD 45

366
SIR EDWARD BURNE-JONES
(1833-1898)

MRS SITWELL (LATER LADY COLVIN)
Pencil. 380:355

Frances Fetherstonhaugh (1839-1924), married first, the Rev. Albert Sitwell, secondly (in 1903) Sir Sidney Colvin, Keeper of Prints and Drawings from 1884 to 1912.

1927-9-3-1

367
DANTE GABRIEL ROSSETTI
(1828-1882)

MRS WILLIAM MORRIS
Pen and brown ink over pencil. 284:437
Dated, *6th January 1872.*

See nos. 370, 371. Mrs Morris's beauty was the inspiration behind much of Rossetti's later work.

1954-5-8-2, bequeathed by Cecil French

368
SIR JOHN EVERETT MILLAIS
(1829-1896)

HEAD OF A GIRL
Watercolour over pencil. 220:192
Signed with monogram and dated, *1852.*

1967-10-14-124, bequeathed by Dr Eric Millar

369
DANTE GABRIEL ROSSETTI
(1828-1882)

ELIZABETH SIDDALL
Pencil. 185:118

Elizabeth Eleanor Siddall (1834-1862), Rossetti's constant companion and model, whom he married in 1860.

1910-12-10-5, bequeathed by Colonel Gillum

370
WILLIAM MORRIS
(1834-1896)

JANE BURDEN, LATER MRS WILLIAM MORRIS
Pencil and pen and black ink. 104:75

Jane Burden (1840-1914), married Morris in April 1859.

1939-6-2-1, presented by Dr Robert Steele

371
CHARLES GERE
(1869-1957)

MRS WILLIAM MORRIS
Pencil and white bodycolour on parchment. 196:165

Drawn c. 1900.

See no. 370.

1974-4-6-15, presented by J. A. Gere

372
FREDERICK LEIGHTON
(1830-1896)

WALTER CREYKE
Pencil. 230:182
Signed with monogram and dated, *1855.* Inscribed: *W. Creyke from his sincere friend Fred Leighton.*

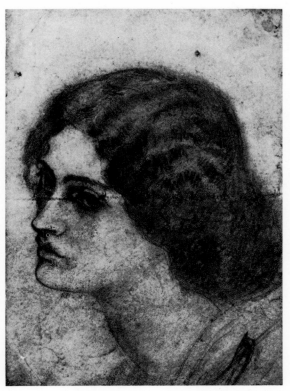

370 WILLIAM MORRIS
JANE BURDEN LATER MRS. WILLIAM MORRIS

Walter Pennington Creyke (1828-1892).

1957-4-12-7, bequeathed by D. A. Macalister

373

GEORGE HOWARD, 9th Earl of CARLISLE
(1843-1911)

FREDERICK SITWELL ON HIS DEATHBED
Pencil. 170:350 (octagonal)
Dated, *April 27 1873.*

Frederick Sitwell (d. 1873), the younger son of
Lady Colvin (see no. 366), by her first husband,
the Rev. Albert Sitwell.

1927-9-3-2, bequeathed by Sir Sidney Colvin

374

MARIANO FORTUNY
(1838-1874)

THE ARTIST'S WIFE
Watercolour and bodycolour over pencil on grey paper.
492:378
Signed on a label formerly on the back of the
frame, and inscribed: *portrait de la femme de
l'artiste . . . à Portici en 1874.*

1950-5-20-6, presented by Mariano Fortuny y
Madrazo
Transparency PD 70

375

RUDOLF JULIUS BENNO HÜBNER
(1806-1882)

FELIX MENDELSSOHN ON HIS DEATHBED
Pencil and white bodycolour on brown paper. 296:382
Signed with monogram and inscribed: *Felix
Mendelssohn Bartholdy auf den Todtenbette gezeich-
net auf der Natur.*

Felix Mendelssohn (1809-1847), composer.

1939-1-14-1, presented by Mrs Emile Mond.

376

MARGARET GILLIES
(1803-1887)

RICHARD HENGIST HORNE
Brush-drawing in pinkish wash. 183:150 (oval)

Richard Hengist Horne (1803-1884), man of
letters. Known as the 'Farthing Poet' from the fact
that his best-known work, the epic poem *Orion*,
was first published at the price of one farthing.

1885-5-9-1608

377

RICHARD DOYLE
(1824-1883)

WILLIAM MAKEPEACE THACKERAY
Pencil. 242:154

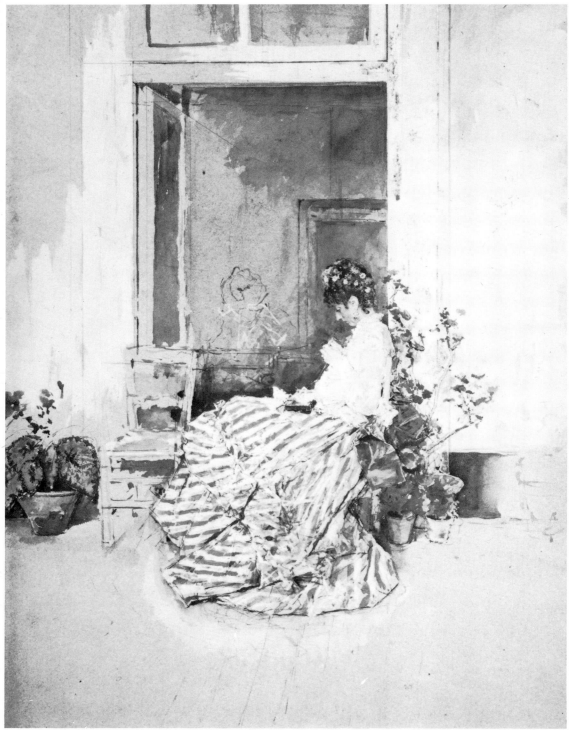

374 MARIANO FORTUNY
THE ARTIST'S WIFE

William Makepeace Thackeray (1811-1863), novelist.

1886-6-19-7

378
GEORGE SCHARF
(1820-1895)

HENRY CRABB ROBINSON
Pencil. 133:144
Signed and dated, *September 4th 1860* and inscribed: *sketched from life at the Athenaeum Club.*

Henry Crabb Robinson (1775-1867), diarist and friend of literary men. One of the founders of the Athenaeum Club and of University College, London. (The drawing is mounted with a copy of a miniature, dated 1811, showing him as a younger man.)

379
SIR EDWARD POYNTER, P.R.A.
(1836-1919)

MRS FORSTER
Pencil. 188:134
Signed with monogram and dated, *Paris, 1855.* Inscribed with the sitter's initials.

Lavinia Banks (1774-1858), daughter of the sculptor Thomas Banks, R.A., married the Rev. Edward Forster in 1799. Their daughter was the mother of Edward Poynter.

1965-12-11-30, presented by Charles Bell
Transparency PD 34

380
RUDOLF LEHMANN
(1819-1905)

MRS HUMPHRY WARD
Black chalk touched with white chalk on brown paper. 284:218
Signed with monogram and dated, *Haselmere Sept. 22 1890.*

Mary Augusta Arnold (1851-1920), grand-daughter of Dr Arnold of Rugby, niece of Matthew Arnold, and aunt of Aldous Huxley; novelist and social worker. Married Humphry Ward, 1872.

1906-4-19-46

381
SAMUEL LAURENCE
(1812-1884)

'GEORGE ELIOT'
Black chalk. 501:388
Inscribed: *First study for the portrait of George Eliot by Samuel Laurence, 1860.*

Mary Ann Evans (1819-1880), novelist, using the pseudonym of George Eliot

1936-7-2-3

382
LOWES CATO DICKINSON
(1819-1908)

(a) SIDNEY FRIPP
 Pencil. 171:119
 Dated, *Naples, August 1851.*

(b) – JESSOP
 Pencil. 169:115
 Dated, *Naples, Oct* (the rest cut away)

Two of a group of seven pencil sketches of the artist's friends and companions in Italy, where he was studying between 1850 and 1853.

1909-3-2-11 and 9, presented by Miss Lowes Dickinson

383
JOHN SINGER SARGENT
(1856-1925)

TWO STUDIES OF MADAME GAUTREAU
Pencil. 240:335

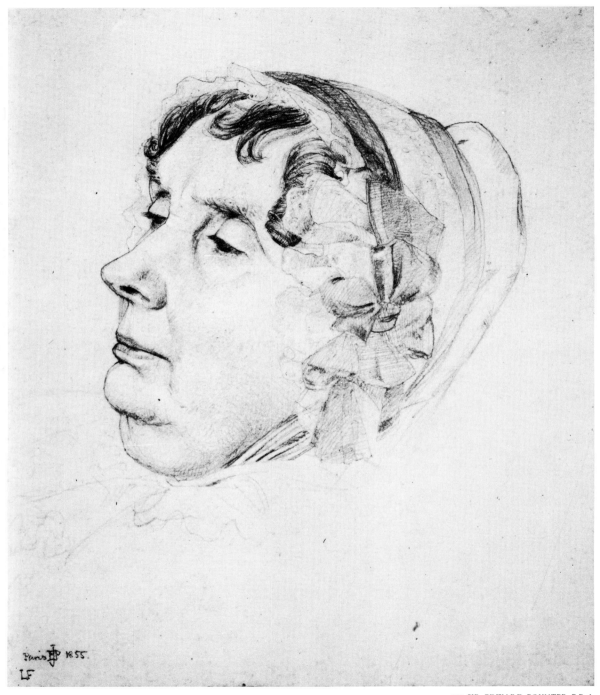

379 SIR EDWARD POYNTER P.R.A.
MRS FOSTER

Virginie Avegno, born in Louisiana, was the wife of a wealthy Parisian banker, M. Pierre Gautreau. Sargent's portrait of her, now in the Metropolitan Museum of Art, New York (a version, unfinished, is in the Tate Gallery) was exhibited at the Paris Salon of 1884. The hostile criticism it provoked was largely responsible for Sargent's decision to settle in England. In the painting, Madame Gautreau is standing. This study represents an earlier idea, in which she was to have been seated.

1936-11-16-3, presented by Mrs Ormond

384
FRANCIS DODD
(1874-1949)

WILLIAM BOOTH
Pen and black ink. 294:260
Signed with monogram.

'General' William Booth (1829-1912), founder of the Salvation Army.

1912-8-28-1

385
SIR FRANK LOCKWOOD, Q.C.
(1846-1897)

(a) LORD CROFTON
(b) MRS WILSON (OF TRANBY CROFT)
(c) THE EARL OF COVENTRY
 Pencil. Each 216:130

Edward Crofton, 3rd Lord Crofton (1834-1912); George William Coventry, 9th Earl of Coventry (1838-1930).

 Sketches made in court of three of the witnesses for the defence in the so-called 'Baccarat case' in June 1891, an action for slander brought by one of the guests at a houseparty at Tranby Croft, Mr Arthur Wilson's house in Yorkshire, who had been accused of cheating at baccarat. Scandal was caused by the Prince of Wales (later Edward VII) being called as a witness for the defence.

1915-11-8-9, 10 and 11, presented by E. E. Leggatt

386
ALPHONSE LEGROS
(1837-1911)

A. P. TROTTER
Metalpoint on pink prepared paper. 225:181
Signed and dated, *1895.*

A study for the etching (S.524)

1953-4-22-5, presented by G. J. F. Knowles

387
SIR WILLIAM ROTHENSTEIN
(1872-1945)

JOHN DAVIDSON
Pastel. 358:323

John Davidson (1857-1909), poet. Author of *Fleet Street Eclogues.*
'Looking at my drawing of Davidson, Max [Beerbohm] remarked on the subtle way in which I had managed his toupee; greatly to my surprise, for I had not noticed, to Max's amusement, that he wore one. How much more observant was Max than I! He told me that Davidson was far from wishing to look younger than in fact he was, but having to depend on journalism for a living, he feared a bald head would prejudice his chances', William Rothenstein, *Men and Memories*, i, chapter XV.

1925-8-17-2, presented by Henry van den Bergh through the National Art-Collections Fund.

388
ALTHEA GYLES
(fl. c. 1895)

W. B. YEATS
Indian ink. 245:166
Signed with initials.

William Butler Yeats (1865-1939), poet. The

drawing was introduced as a frontispiece for one of his early books, *The Wind among the Reeds*, published in 1899.

1954-5-8-37, bequeathed by Cecil French

389
WILLIAM STRANG
(1859-1921)

THOMAS HARDY
Pencil. 292:214
Signed and inscribed, *to J. Craig Annan.*

Thomas Hardy (1840-1928), poet and novelist.

1928-1-31-1, presented by Craig Annan
Transparency PD 33

390
WILLIAM STRANG
(1859-1921)

WILLIAM SHARP
Metalpoint on pale blue-grey prepared paper. 352:250

William Sharp (1855-1905), man of letters, poet of the 'Celtic Twilight' under the pseudonym Fiona Macleod.

1897-12-13-6, presented by the Artist

391
CHARLES WELLINGTON FURSE
(1868-1904)

ELEANOR BUTCHER
Red chalk. 463:354

Eleanor (d. 1894), sister of S. H. Butcher, the translator (with Andrew Lang) of *The Odyssey*. Shortly before her death she became engaged to Charles Furse.

1930-8-21-1, presented by Dame Katherine Furse

392
EDMOND XAVIER KAPP
(b. 1890)

FREDERICK DELIUS
Conté crayon. 428:320
Signed and dated, *Grez-sur-Loing, 1932.*

Frederick Delius (1862-1934), composer.

1933-7-27-1, presented anonymously

393
A. HUGH FISHER
(1867-1945)

JAMES STEPHENS
Pencil. 230:292
Signed and dated, *1941.*

James Stephens (1880?-1950), poet. Author of *The Crock of Gold.*

1945-12-8-20, presented by the Contemporary Art Society

394
ALBERT LUDOVICI
(1820-1894)

GEORGE BERNARD SHAW
Pencil and watercolour. 137:99
Signed and inscribed: '. . . *if every time this piece is to be played I am called upon to make a speech, my powers of oratory will soon be exhausted*' (laughter). *Dec 13, 1892.*

George Bernard Shaw (1856-1950), playwright. He is here shown making a speech before the curtain after one of the first performances of his play *Widowers' Houses*, produced at the Royalty Theatre on 9 December 1892. The drawing is on the back of the programme cover.

1939-5-13-57, presented by Dr Robert Steele

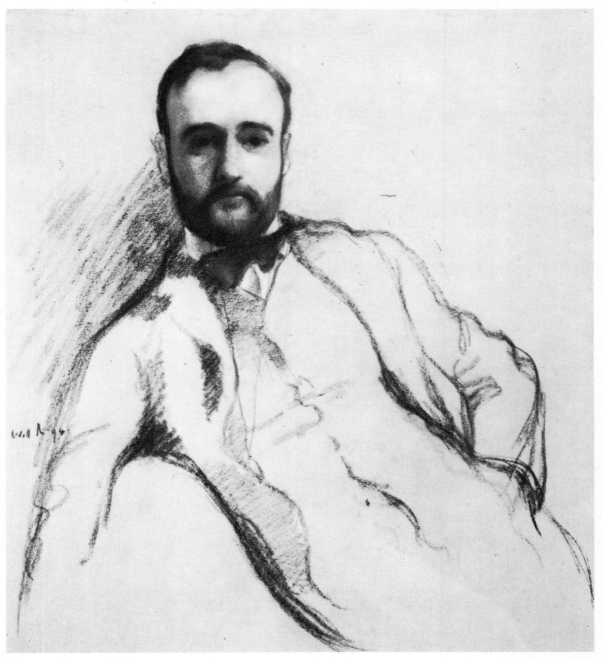

387 SIR WILLIAM ROTHENSTEIN
JOHN DAVIDSON

395
EDMUND J. SULLIVAN
(1869-1933)

JOHN GALSWORTHY
Pencil. 227:168

John Galsworthy (1867-1933), novelist and play-wright.

1939-3-15-1

396
LEONHARD FANTO
(b. 1874)

SIR ROGER CASEMENT
Black and white chalk on grey paper. 523:390
Signed and dated, *1916*.

Sir Roger Casement (1864-1916), British consular official and Irish patriot. Hanged for High Treason. This portrait was made in Germany shortly before his abortive expedition to Ireland in April 1916.

1937-7-10-14, presented by the Contemporary Art Society

397
FRANCIS DODD
(1874-1949)

CAMPBELL DODGSON
Black chalk on greyish-green paper. 329:249
Signed and inscribed: *study for Campbell Dodgson Esq.*

Campbell Dodgson (1867-1948), Keeper of Prints and Drawings from 1912 to 1932. The drawing is a study for an etching dated 1908.

1967-12-9-7

398
AMBROSE McEVOY
(1878-1927)

PORTRAIT OF A LADY

Pencil and brown wash. 509:357

1935-6-8-10, presented by a body of subscribers

399
ROBIN GUTHRIE
(b. 1902)

STUART GUTHRIE
Pen and indian ink and grey wash, corrected in white bodycolour. 165:229
Signed.

1927-2-12-81, presented by the Contemporary Art Society

400
POWYS EVANS
(b. 1899)

H. M. TOMLINSON
Pen and indian ink, with touches of white bodycolour (also used to correct the contour of the face on the left). 201:164
Signed and dated, *1926*.

Henry Major Tomlinson (1873-1958), writer.

1930-1-11-5, presented by the Contemporary Art Society

401
SIR GEORGE CLAUSEN
(1852-1944)

HENRY FESTING JONES
Pencil. 265:210
Signed with initials and dated, *Feb. 16th 1923*.

Henry Festing Jones (1851-1928), man of letters, collaborator with and biographer of Samuel Butler.

1934-3-10-21, presented by the Contemporary Art Society

402
FREDERICK CAYLEY ROBINSON
(1862-1927)

CECIL FRENCH
Pencil, with touches of blue and pink watercolour.
278:240
Signed and dated, *1917.*

Cecil French (d. 1953), collector, benefactor to the Department of Prints and Drawings.

1954-11-4-11, presented by David Gould

403
DERWENT LEES
(1885-1931)

FRANCIS HELPS
Pencil and watercolour. 470:298

Francis Helps (b. 1891), artist.

1939-10-14-23

404
ERIC HENRI KENNINGTON
(1880-1960)

A GERMAN SOLDIER
Blue crayon. 259:204
Signed and dated, *(19)17.*

1918-12-21-1, presented by the Artist

405
JOSEPH SIMPSON
(1879-1939)

THE EARL OF LONSDALE
Black chalk. 288:253
Signed.

Hugh Lowther, 5th Earl of Lonsdale (1857-1944), a well-known personality in the world of sport, racehorse-owner and amateur boxer. Known as 'The Yellow Earl' from the colour of his carriages and livery.

1944-4-19-1, presented by J. Stewart Nicoll

406
JAMES McBEY
(1883-1959)

VISCOUNT ALLENBY
Conté crayon. 253:279
Signed and dated, *Bir Salem, September 1918.*

Edmund Henry Hyndman Allenby, 1st Viscount Allenby, Field-Marshal (1861-1936). Commander of the British forces in the Near East, 1917-18.

1919-4-12-16, presented by H.M. Government

407
STANLEY SPENCER
(1892-1959)

HEAD OF A BEARDED MAN
Pencil. 354:254

1936-6-13-32, presented by the Contemporary Art Society

408
JOHN WHEATLEY
(1892-1955)

W. H. DAVIES
Pen and brown ink and pink and grey wash. 253:352
Signed and dated, *1919.*

William Henry Davies (1871-1940), poet. Author of *The Autobiography of a Super-Tramp,* 1908.

1924-2-9-11, presented by the Contemporary Art Society
Transparency PD 46

409
WILLIAM STRANG
(1859-1921)

MISS FRANCES POYNTER
Black and red chalk. The necklace in brown chalk with touches of yellow bodycolour. 459:297
Signed and dated, *Old Headington, 16 Sept 1913;* also signed by the sitter.

Emma Frances (b. 1840), younger sister of Sir Edward Poynter, P.R.A.

1964-12-12-12, presented by Charles Bell

410
PERCY WYNDHAM LEWIS
(1882-1957)

PORTRAIT OF A LADY
Pencil and pale brown wash. 479:385
Signed and dated, *1923.*

1954-9-28-2, presented by the Contemporary Art Society

411
CLAUDE ROGERS
(b. 1907)

PROFESSOR J. B. S. HALDANE
Pencil. 269:385

John Burdon Sanderson Haldane (1892-1964), biologist and geneticist. A study for the portrait painted in 1957 for University College, London.

1974-4-6-6

412
DAVID HOCKNEY
(b. 1937)

'NICK AND HENRY ON BOARD. NICE TO CALVI'
Pen and ink. 433:355

Inscribed as above, signed with monogram and dated, *July 18th 1972.*

1972-12-9-5

INDEX OF ARTISTS

INDEX OF SUBJECTS